Another Way of Telling

John Berger Jean Mohr

with the help of
Nicholas Philibert

Vintage International
Vintage Books
A Division of Random House, Inc. New York

FIRST VINTAGE INTERNATIONAL, FEBRUARY 1995

Copyright © 1982 by John Berger and Jean Mohr

All rights reserved under International and Pan-American Copyright Conventions. Published in the United States by Vintage Books, a division of Random House, Inc., New York, and simultaneously in Canada by Random House of Canada Limited, Toronto. Originally published in hardcover by Pantheon Books, New York, in 1982.

The Library of Congress has catalogued the Pantheon edition as follows:

Berger, John.

Another way of telling.

1. Photography, Artistic. I. Mohr, Jean.
II. Title.

TR183.B45 770'.1 81-47186 ISBN 0-394-51294-4 AACR2 ISBN 0-394-73998-1 (pbk.)

Vintage ISBN: 0-679-73724-3

Manufactured in the United States of America

10 9 8

OF ART & DESIGN

John Berger and Jean Mohr Another Way of Telling

John Berger's first novel, A Painter of Our Time, was published in 1958. Since then, his fiction has included the novel G. (which won the Booker Prize in 1972) and the acclaimed trilogy Into Their Labours, which is composed of Pig Earth, Once in Europa, and Lilac and Flag. Mr. Berger is equally renowned as an art critic and essayist and is the author of The Sense of Sight, About Looking, and Ways of Seeing. He lives and works in a small village in the French Alps.

Jean Mohr has been for many years a photographer for international institutions and magazines. He lives in Geneva, Switzerland. In addition to *Another Way of Telling*, Mr. Mohr has collaborated with Mr. Berger on *A Fortunate Man* and *A Seventh Man*.

Works of JOHN BERGER

Pig Earth (the first volume of the Into Their Labours trilogy)

Once in Europa (the second volume of the trilogy)

Lilac and Flag (the third volume of the trilogy)

A Painter of Our Time

Permanent Bed

The Foot of Clive

Corker's Freedom

A Fortunate Man*

Art and Revolution

The Moment of Cubism and Other Essays

The Look of Things: Selected Essays and Articles

Ways of Seeing

Another Way of Telling*

A Seventh Man*

G.

About Looking

And Our Faces, My Heart, Brief as Photos

The Sense of Sight

The Success and Failure of Picasso

Keeping a Rendezvous

To the Wedding

King

Photocopies

The Shape of a Pocket

Selected Essays

*works done in collaboration with Jean Mohr

This book would not have been possible without the support, both financial and theoretical, of the Transnational Institute, Amsterdam. I would like, once again, to express my solidarity with this Institute. J.B.

Contents

Preface 7

Beyond my camera

9

Appearances

81

If each time ...

131

Stories 277

Beginning 291

List of Photographs

295

Preface

We wanted to make a book of photographs about the lives of mountain peasants. During seven years the men and women from our village and in the nearby valleys have collaborated with us. What we show is in the most profound sense their life's work.

We also wanted to produce a book about photography. Everyone in the world is now familiar with photographs and cameras. And yet what is a photograph? What do photographs mean? How can they be used? Such questions which began to be asked with the invention of the camera have not, until now, been fully answered.

Our book is divided into five parts. In the first, Jean Mohr writes about aspects of his experience as a photographer, and particularly those aspects which illustrate how photographs are ambiguous. A photograph is a meeting place where the interests of the photographer, the photographed, the viewer and those who are using the photograph are often contradictory. These contradictions both hide and increase the natural ambiguity of the photographic image.

The second part is an essay which explores a possible theory of photography. Most theoretical writing about the medium has limited itself to either the purely empirical or to the purely aesthetic. Yet photography naturally leads to the question of the meaning of appearances in themselves.

The third part of our book consists of a sequence of a hundred and fifty photographs without words. This sequence entitled "If Each Time..." is a reflection upon a peasant woman's life. It is not a reportage. We hope that it may read as a work of imagination.

The fourth part discusses some of the theoretical implications of the way we have tried to tell a story in "If Each Time . . .". The final very brief section is a reminder of the reality from which we began: the life work of peasants.

Beyond my camera

by Jean Mohr

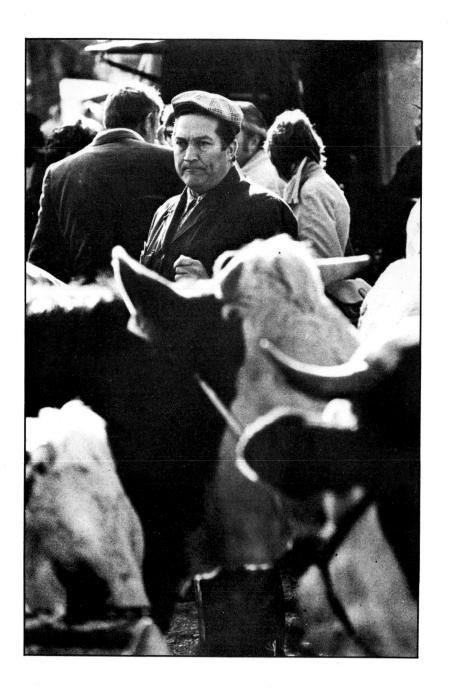

WHAT ARE YOU DOING THERE?

A Sunday afternoon in autumn. The large market square of the country town of B . . . It was sunny, but it wasn't a sun that warmed, it simply shone with its violent light on people and things. Some were directly in this light, some were in shadow. There were no half-measures about this light. The peasants from the neighbouring countryside paid little attention to the quality of light, they had come to the fair to buy or sell cattle.

As for me this violent sunlight posed certain technical problems. I would have preferred a cloudy sky, even mist. Making my way between the cattle, the peasants and the cattle dealers, I was looking for some angle of approach. Warming-up — in both senses of the word. I wasn't playing any games, I don't like that, I wasn't pretending not to take photographs. In any case it's not easy to trick a Savoyard peasant. And I prefer to be frank about what I'm doing, whenever it's possible.

Near a line of calves some men were talking. Dryly. They had seen me but were pretending to ignore me. Suddenly one of them spoke out, not really aggressively, but rather more to amuse his colleagues.

"So what are you doing there?"

"I'm taking some pictures of you and your cattle."

"You're taking some pictures of my cows! Would you believe it? He's helping himself to my cows without having to pay a sou for them!"

I laughed along with the others. And I went on *taking* my photos. That is to say, taking in my own way what was before my eyes and what interested me, without paying and without asking permission.

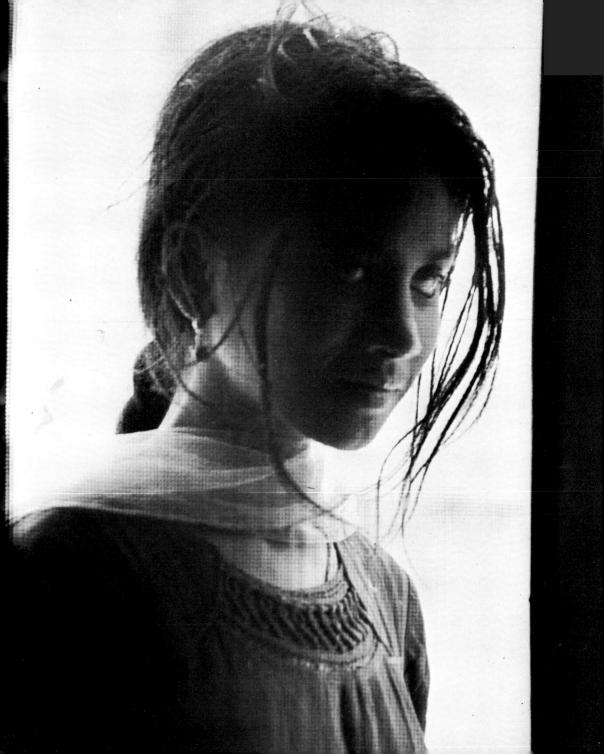

THE STRANGER WHO IMITATED ANIMALS . . .

I was visiting my sister, who lives in the university town of Aligarh in India. The previous evening, when I first arrived, she had warned me: "Don't be surprised if you're woken up early in the morning. There's a young girl, a neighbour, who is blind, but who likes to know what is happening. She may well come to see who the new arrival is."

Tired by the long journey in the train that had stopped at every station, I quickly fell asleep. And when I awoke next morning, it took me several minutes to remember where I was. I could hear something scratching near the window, a fingernail lightly rasping against the mosquito net. The young blind girl said Good Morning. The sun had been up for several hours.

Without reasoning why, I replied to her by yapping like a dog. Her face froze for a moment. Then I imitated a cat caterwauling. And the expression on her face behind the netting changed to one of recognition and complicity in my play-acting. I went on to a peacock's cry, a horse whinnying, a large animal growling – like a circus. With each act and according to our mood, her expression changed. Her face was so beautiful that, without stopping our game, I picked up my camera and took some pictures of her.

She will never see these photographs. For her I shall simply remain the invisible stranger who imitated animals.

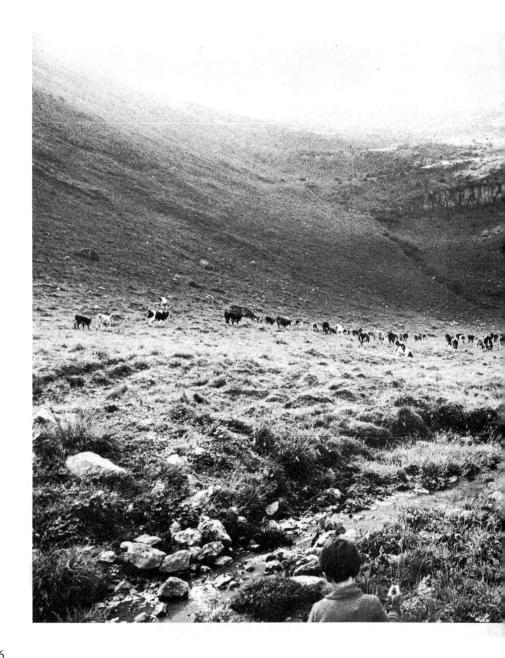

MARCEL OR THE RIGHT TO CHOOSE

During the summer Marcel lives and works alone in the *alpage*, at an altitude of 1,500 metres. He has a herd of fifty cows. Occasionally his young grandson pays him a visit. He seemed to enjoy the two days I spent with him. I was a kind of company for him.

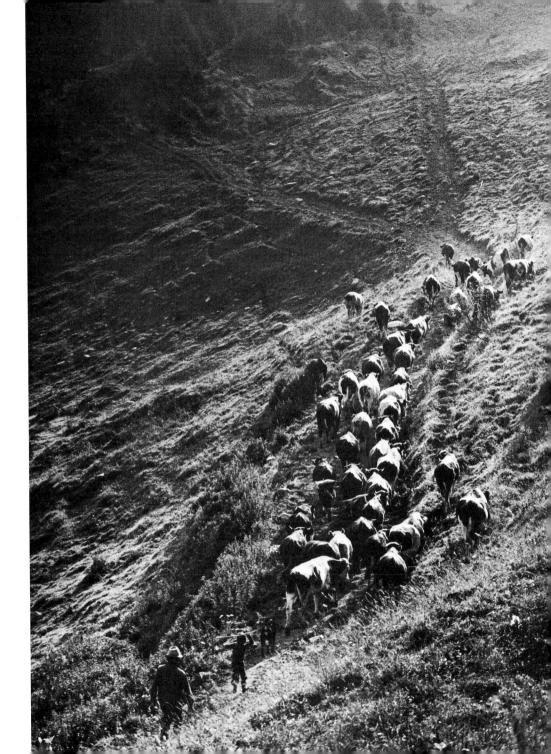

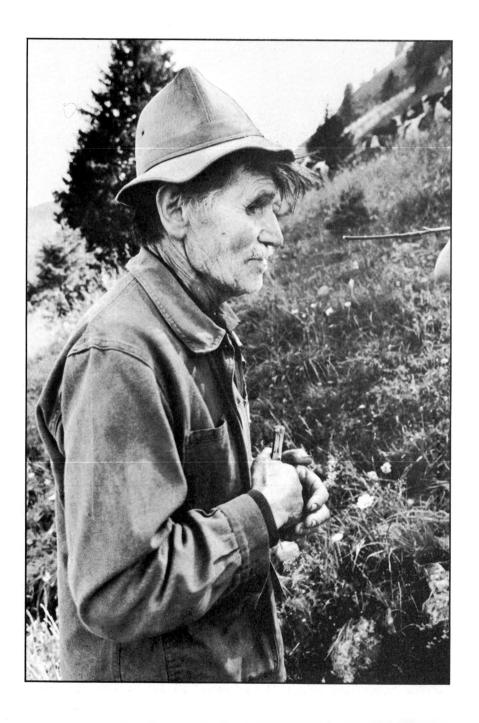

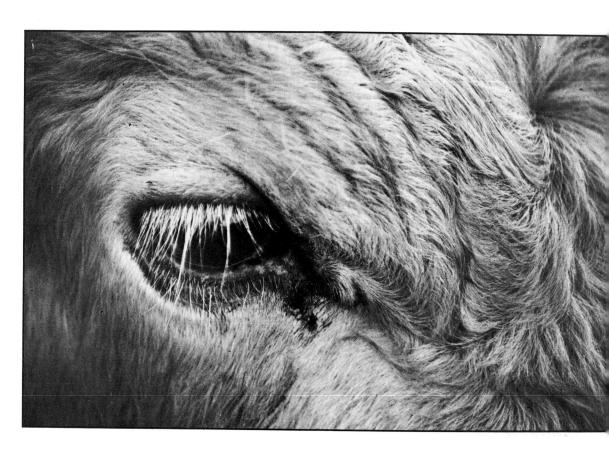

The following Saturday when I took him a pile of prints, he examined them very carefully, spreading them out on the kitchen table. Pointing his finger at a close-up of a cow's eye, he said categorically: "That's no subject for a photo!"

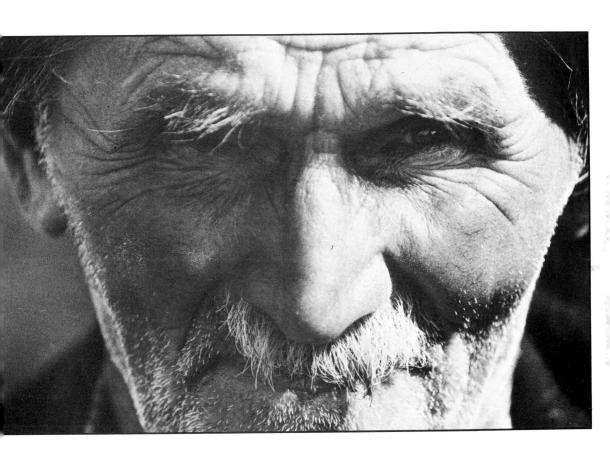

Silence. Then he added: "But don't think I can't tell which cow it is! That's Marquise." Another silence. "The same principle," he continued, "applies to pictures of people. If you take a head, you should take the whole head, the whole head and shoulders. Not just a part of the face."

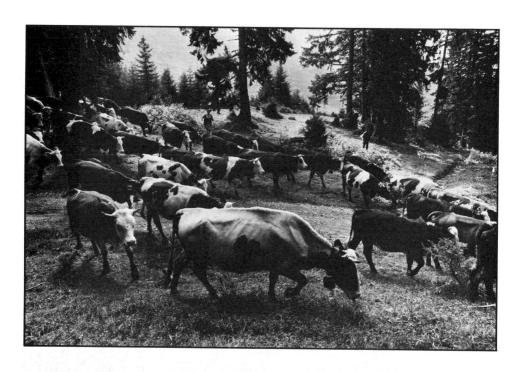

"That's very good! It's all there." He picked out the pictures he liked best. They were those which showed what gave pleasure to him in his life. His large herd. His grandson. His dog.

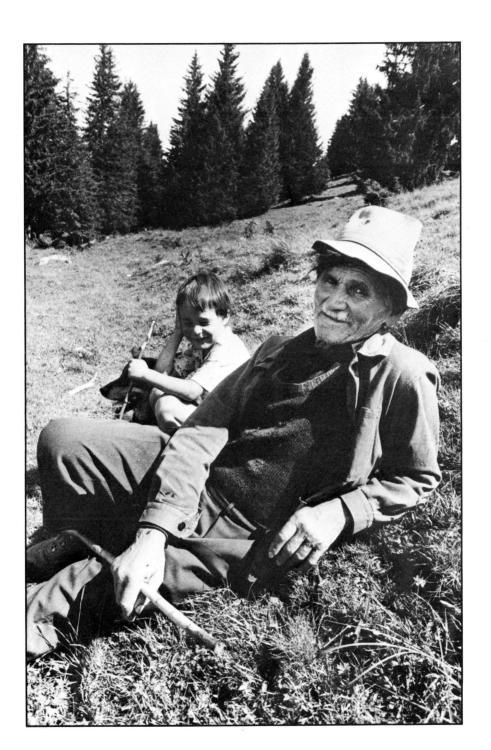

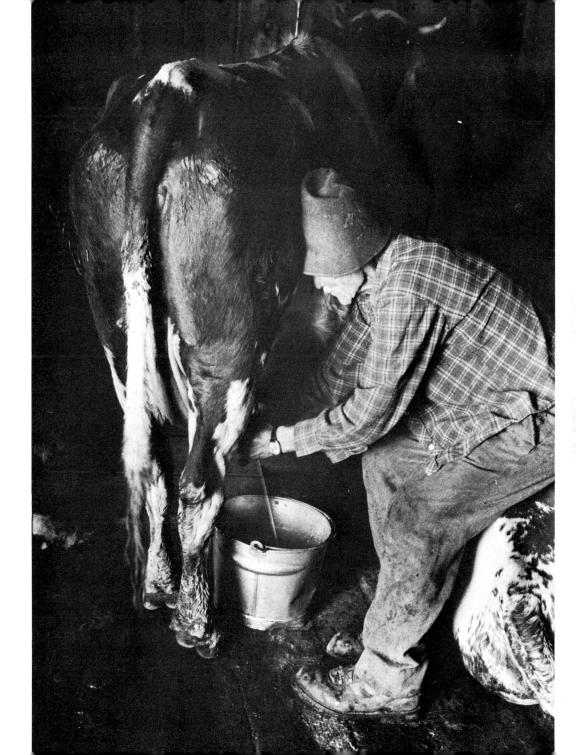

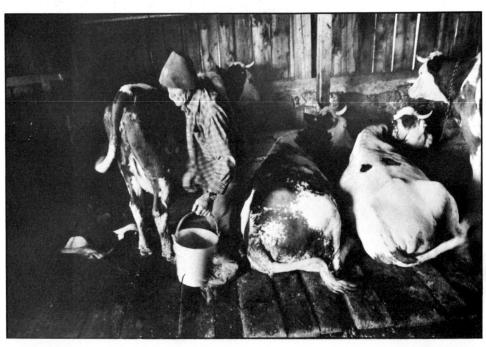

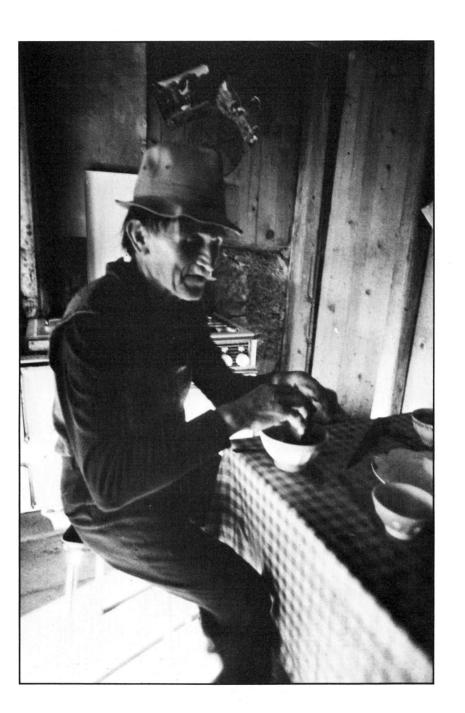

The next Sunday, early in the morning, Marcel knocked at the door. He was wearing a clean, freshly ironed, black shirt. His hair was carefully combed. He had shaved. "The moment has come," he told me, "to take the bust. Down to there!" He indicated his waist with one hand. Below this chosen line he was wearing his working trousers and his boots covered with cowshit. Sunday or not, he still had fifty cows to look after. He stood in the middle of the kitchen and concentrated on the camera which was going to take his portrait.

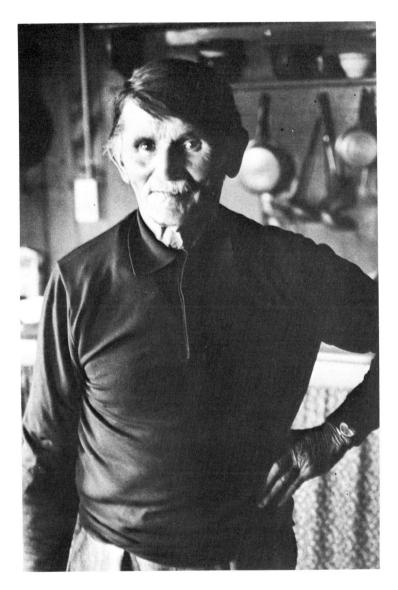

When he saw this portrait, in which he had chosen everything for himself, he said with a kind of relief: "And now my great grandchildren will know what sort of man I was."

SELF-PORTRAIT

To make successful portraits, it probably helps to have taken some self-portraits, and also to have learnt to accept the photographs others have taken of yourself. Otherwise, how is it possible to understand the embarrassment, the worry, even the panic, which often assails people when they know they are being photographed?

For myself, I'm not too fat, my nose is large but not unreasonably long. And yet for years I could not accept my own physical appearance. I used to dream of looking like Samuel Beckett. (To have a profile like his would perhaps also imply another way of life.) I took a number of self-

portraits, and each time I "disguised" my face because I rejected it totally. I grimaced, I played tricks with the light, I deliberately moved the camera. The cure for this play-acting came when I was obliged to look at myself for the whole length of a television film — a film called *A Photographer Among Men*, made by Claude Goretta. There the dose was strong enough to cure me. This man whom I saw before me existed with all his weaknesses. He was real, and in a sense he was beyond my control. I was no longer responsible for his appearances.

Several years later, during a seminar I was conducting on photography, it was decided that we'd each in turn take photographs — portraits — of each other. When my turn came to pose, one of the students casually remarked: "In this light your face reminds me a little of Samuel Beckett's."

WHAT DID I SEE?

Was it a game, a test, an experiment? All three, and something else too: a photographer's quest, the desire to know how the images he makes are seen, read, interpreted, perhaps rejected by others. In fact in face of any photo the spectator projects something of her or himself. The image is like a springboard.

I often feel the need to explain my photos, to tell their story. Only occasionally is an image self-sufficient. This time I decided to allot the task of explanation to others. I took a number of photographs from my archives and I went out to look for those who would explain them. Of the ten people I asked, only one refused. He was an old gardener and he said it was too much like a television guessing-game.

All the others agreed to describe what came into their minds when presented with the photo I was showing them. I said nothing myself, simply noting what was said. The choice of people was largely a matter of chance. Some were acquaintances, others I was seeing for the first time.

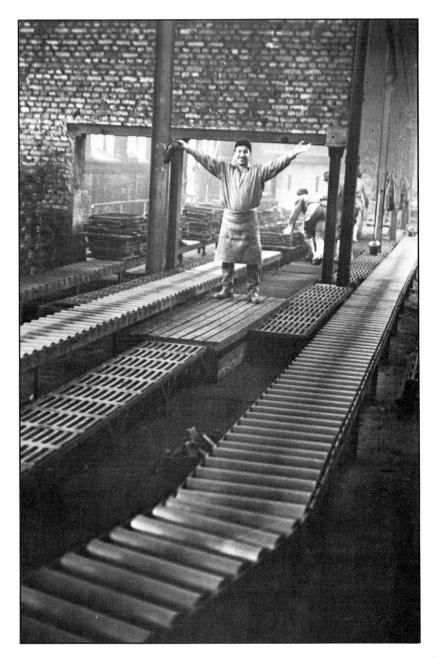

43

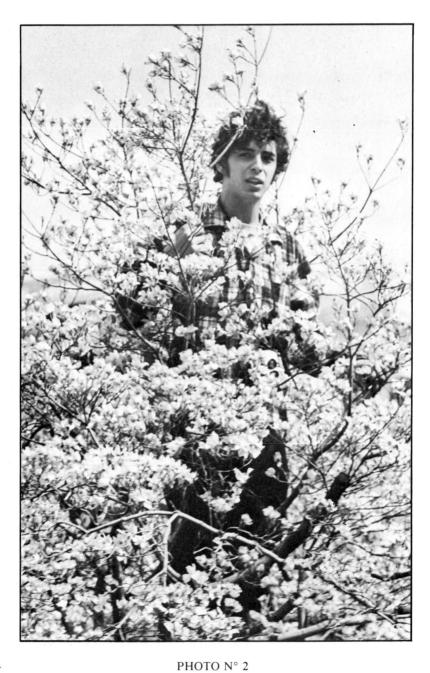

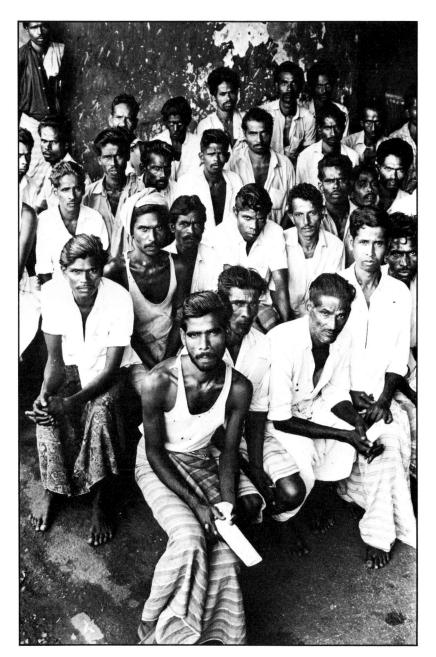

PHOTO N° 3

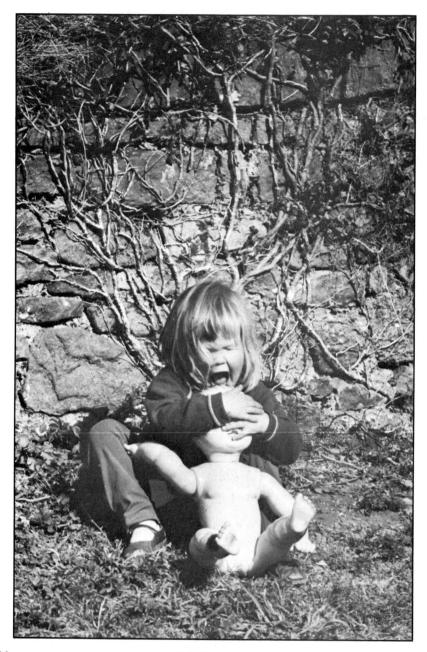

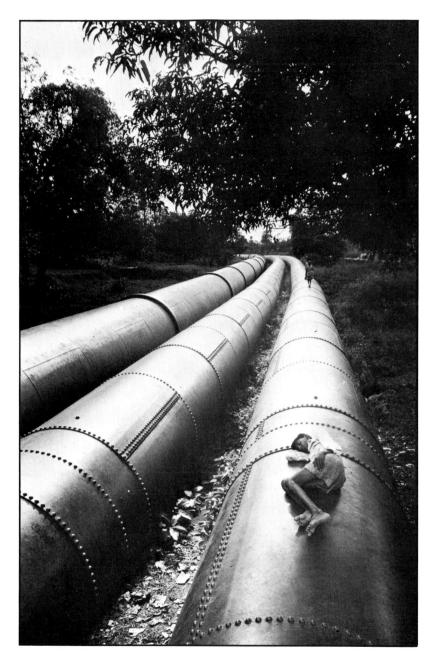

PHOTO N° 5

- E. J., market-gardener: According to the social position you find yourself in, the fact of being able to work, even if it's hard, is a positive joy.
- *H. M.*, *clergyman:* A happy worker who isn't ashamed. I find his gesture, as he turns towards us, fantastic. His gestures are the opposite of a dictator's. Marvellous. He moves me and he's making no concessions. I admire a chap like that.
 - C. M., schoolgirl: Somebody who's happy. He has finished work.
- A. R., banker: Work makes you healthy! That's the slogan this friendly worker seems to be illustrating for us. But it can only be for a moment, for it's hard to imagine that anyone can be so cheerful when working for eight or ten hours on the production line. Unless he's one of those rare people whose aims are nobler than the common run of mortals!

- A. B., actress: Long live the production line! I feel two things here. The line has stopped. Work is over. The man's happy. He's proud of the workshop. Work's over. My factory is great.
- F. S., dance-teacher: I'm a bit lost. What does it mean? A warehouse? No, there's nothing in it. He likes being photographed. He's happy. He works. He's happy. He could complain, he doesn't. Is he the ideal worker? Perhaps it's the boss? I'd be unhappy there.
- J. J. B., psychiatrist: He's happy the day is over. It's a factory with an assembly line. There's nothing more to do. He's taking off his gloves.
- L. C., hairdresser: Happiness! His way of opening his arms as if to welcome somebody who has just arrived. He looks like a worker who has a hard job and earns little money. It makes me think of the prisoners in the German camps, an armaments factory.
- I. D., factory worker: A coincidence. We have the same rollers in our factory! By his expression I'd say it was Friday night, the end of the week's work. He looks happy, I wish him a good week-end.

What was happening: It was a foundry in West Germany. I was photographing a Yugoslav worker for a reportage made for the International Labour Office. A Turkish worker nearby, seeing me, shouted out: "So there are only Yugoslavs here! Me, I don't exist!" Yes, he existed too, and I took his picture.

Market-gardener: It makes me think of someone who's looking for the best place to take a photo! He enjoys nature. He's a modern type who likes to get out of the city. He looks elsewhere for what he can't find at home.

Clergyman: Tomorrow belongs to the young! An image of hope. His face and his shirt are touching. I have to stop myself saying: Spring!

Schoolgirl: A bloke in a tree which is in flower. He's hiding and playing. And he wants to show to somebody that he's hiding.

Banker: A link between the person and the way the picture has been taken. It's symbolic: youth, beauty, the spring of life. I like his expression, it's healthy, both physically and morally. If only there were more young people like that. Or am I being over hasty? I guess he's an outdoor type who may nevertheless have brains.

Actress: A young man in a flowering tree. Spring. Sexuality. It reminds me of the moment in Fellini's Amarcord when the man exclaims: "I want a woman!" Only here the man is young and the tree is in flower.

Dance-teacher: A chap in a tree with flowers. But he's more realistic than the tree. Youth. Spring. But his face is too tense.

Psychiatrist: A Spanish worker in an orchard full of blossoms. A contrast between the fact that he's proletarian, and it's springtime in the countryside. Yet no, there isn't really a contrast. I can see he's carrying something — but cameras aren't white. He looks surprised but not guilty. Perhaps there's a girl sunbathing in the orchard.

Hairdresser: Somebody high up in a tree. Nothing else. Oh yes. He's a photographer, looking for a picture.

Factory worker: It's pretty, but the flowers would be even prettier in colour. He climbed high up, he has a head for heights, that one.

What was happening: Washington 1971. A demonstration against the war in Vietnam. 400,000 demonstrators in front of the White House. The young man had climbed the tree so as to see better and to take his photographs.

Market-gardener: The eyes of these men tell you about their lives. They've never had anything, or any advantages. Today, when things are changing politically and it seems possible for man to change his fate, such people are becoming aware of the differences between different countries.

Clergyman: Who is going to reply to them? They all look at the camera, they are all waiting for something. I like this photograph. I see in it all the problems of our Christianity. Am I going to offer them the usual *spiel*, or am I going to listen to them and share their waiting?

Schoolgirl: It's a group of poor people and they are waiting to be given something.

Banker: This image immediately brings to mind the stirring of the Asian masses. As racial types, they have fine features, and their expres-

sion suggests that they are questioning the why of their existence, which is probably very precarious.

Actress: My first impression: a group of men like choral music. They are waiting for an answer. Or are they just looking at the photographer? The situation is very tense.

Dance-teacher: These people believe in what? It's frightening, the way they look. One would like to offer them something. Not food—it's not what they're asking for. They are waiting and they are worried. And what will they do to us, if we disappoint them? It's there, in that moment, an uncontrolled force, either positive or negative.

Psychiatrist: I wouldn't like to be in the photographer's shoes. Perhaps it's a political meeting. They are very serious and grave, these men. Scarcely a smile. All of them young. No old people, no children. All of the same age-group.

Hairdresser: They are holding papers in their hands. They must be waiting for a signal. It's in Asia. Men waiting to be vaccinated, or waiting to vote. Their faces are all similar. And the filth. Men waiting to be paid. They are poor.

Factory worker: What country is it? Are they Algerians, perhaps Moroccans? Are they posing for a photograph? It's hard to know what they are doing, or what they are waiting for. From their faces and their eyes, you can see that they don't eat every day.

What was happening: A tea plantation in Sri Lanka. A group of workers came to hear a talk in favour of vasectomy (male sterilisation). After the talk, thirty of them agreed to be operated on straightaway, in the mobile hospital unit outside.

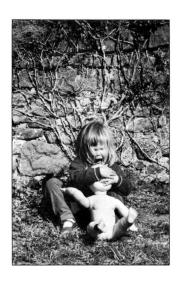

Market-gardener: (Laughs) This one makes me think of a little girl who already has a maternal capacity, and who's treating her doll like it was her own baby. All right, the doll is not pretty and is undressed, but it's hers!

Clergyman: An odd photo. Should one protect children from seeing the cruelty of the world? Should one hide certain aspects of reality from them? Her hands over the doll's eyes shouldn't be there. One ought to be able to show everything, to see all.

Schoolgirl: She's crying because her doll hasn't any clothes.

Banker: Well-fed, well-dressed, such a child is probably spoilt. Given the luxury of no material worries, people can give in to any whim or fancy.

Actress: "My baby is crying but doesn't want to show it." What surprises me is how she hides the doll's face. There's a strong sense of identification between the doll and the child. The girl is playing out what is happening to the doll and what the doll feels. The vine in the background is strange . . .

Dance-teacher: She has everything, yet she doesn't realise it, she is crying with her eyes shut. And the tree behind. The doll is as big as she is.

Psychiatrist: It puzzles me. She's crying as if she has a pain, and yet she's well. She's crying on behalf of her doll, and she covers the eyes as if there was a sight which shouldn't be seen.

Hairdresser: It's a child and somebody has tried to take her doll, which is precious to her. She's going to hold on to it. Perhaps she's German, she's blonde. It makes me think of myself when I was that age.

Factory worker: It's sweet. It reminds me of my niece when her sister tries to take her doll away from her. She's crying, screaming, because someone wants to take her doll away.

What was happening: Great Britain, in the country. A small girl was playing with her doll. Sometimes sweetly, sometimes brutally. At one moment she even pretended to eat her doll.

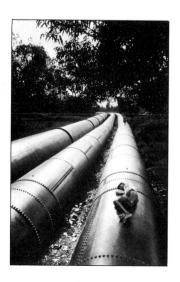

Market-gardener: This reminds me how dependent we are today on the petrol-producing countries, and how it would be better to get on together instead of quarrelling. Today I'm turning off the tap, tomorrow I may open it. That's no way to go on.

Clergyman: Funny! my first reaction: I'd like to be able to sleep like him, without any worries. To sleep is a kind of freedom. Second reaction, more thought out: what have these pipes — petrol? water? — to do with the country and its population? I'd rather he was sleeping against the tree on the left, or in the doorway of a house. He's defying the pipes!

Schoolgirl: This person is lying on that thing to warm himself. Somebody else is coming who thinks the first one is hurt.

Banker: What an unattractive and uncomfortable place to take a siesta! Or is he meant to be on duty, guarding the pipes? No, that's mean. Why is it that what is useful is always so ugly?

Actress: "A rest during a long journey." Is it a pipe-line? A feeling that it goes to the world's end. An image of going-on, and of rest. The direction has already been decided. Everything else in the landscape disappears.

Dance-teacher: How do you get a photo like that? It's crazy, that tiny creature asleep. A man. Just as it was men who made those pipes. But the men who made them never imagined how immense they would look in a photo. They go on and on, those pipes.

Psychiatrist: Pretty extraordinary. What's in the pipes? Perhaps they are warm, yet the country doesn't look like one where people would seek warmth like that. Is it water?

Hairdresser: Water. Massive water-pipes. It's in India. The people are thin. Weary. And the pipes go on and on. Into the distance.

Factory worker: What's flowing along those pipes? Water or fuel? From the way he's sleeping, it looks as though he's earned the right to sleep well.

What was happening: Ponai, thirty kilometres from Bombay. Water pipes taking water to the city. The boy had gone to sleep on the pipes because they were cool.

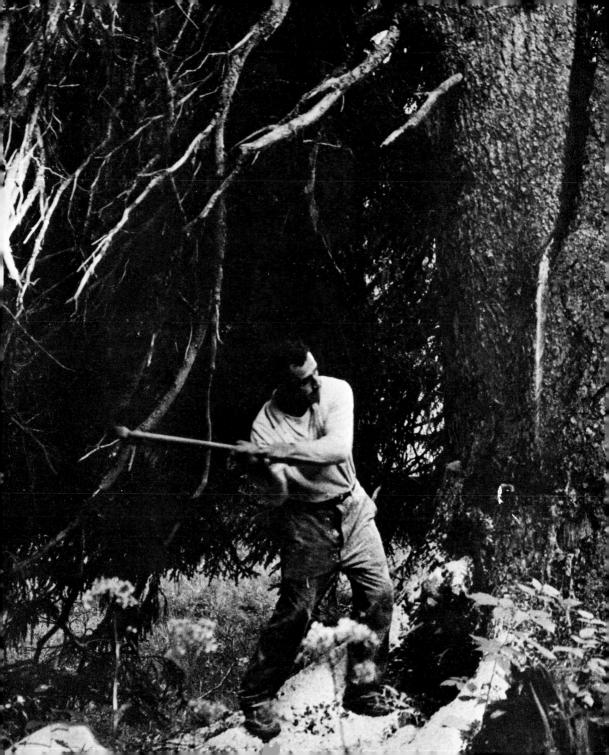

A FRAMED PORTRAIT OF A WOODCUTTER

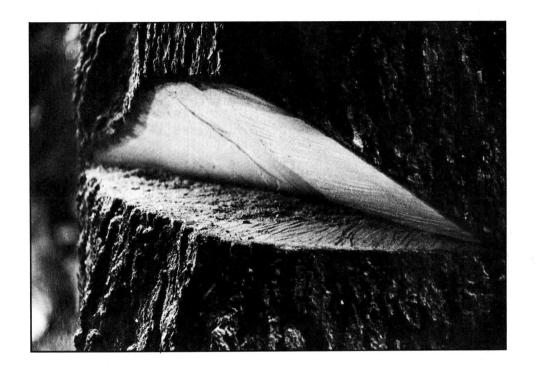

One day the woodcutter's wife stopped in the village and said: "I'd like to ask you a favour. Would you take a photo of my husband? I don't have one, and if he's killed in the forest I won't have a picture to remember him by."

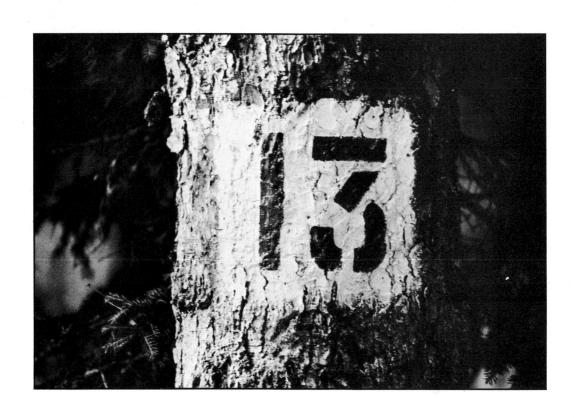

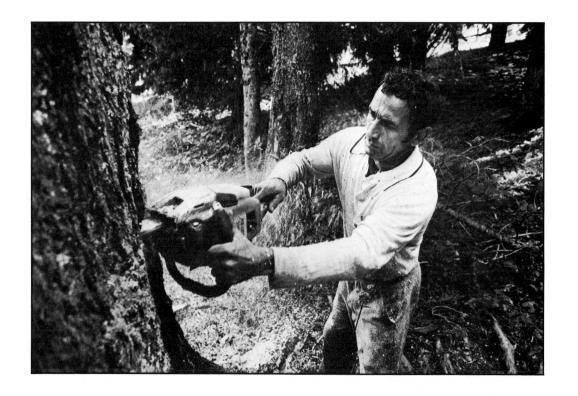

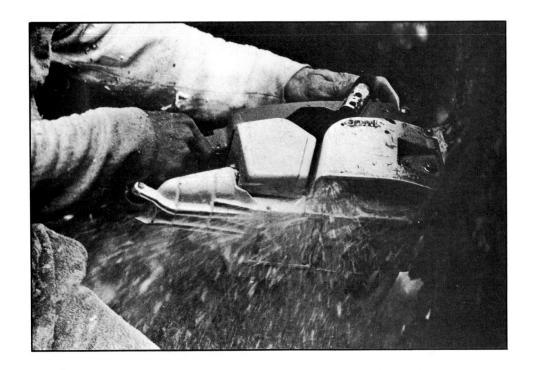

Gaston, unlike most woodcutters, works by himself. He admits that this is more dangerous than working with a team. But he has a passion for forests and likes working alone in them. Also, he works too fast for most other woodcutters. After a few days they leave.

"You can take some pictures," he said, "on condition that they show what the *work* is like."

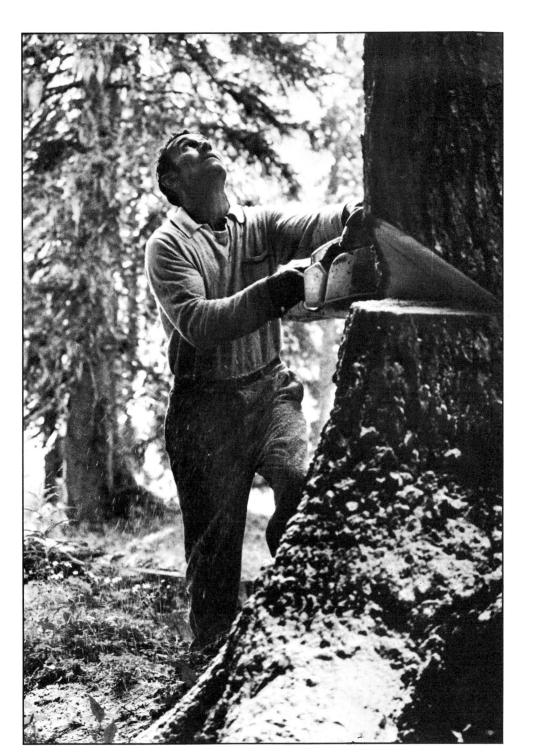

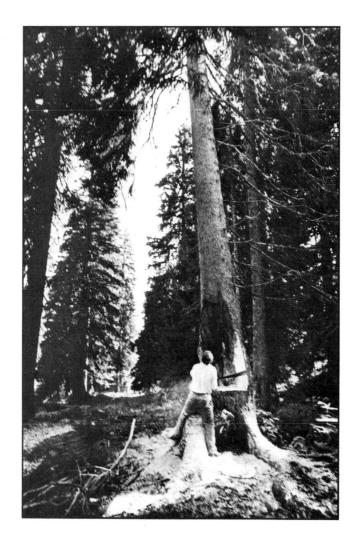

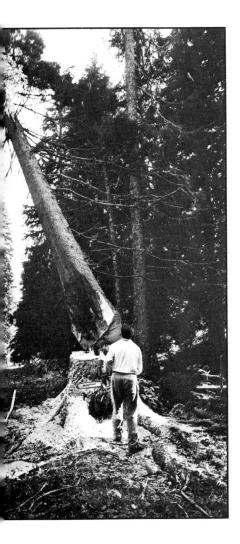

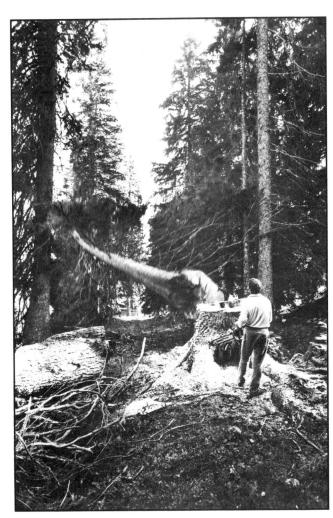

"That's the photo I've dreamt of since I began cutting down trees," he said, "the moment when the tree crashes down and falls exactly where you wanted, so long as you know your job. Falls down twenty centimetres off where you knew it would."

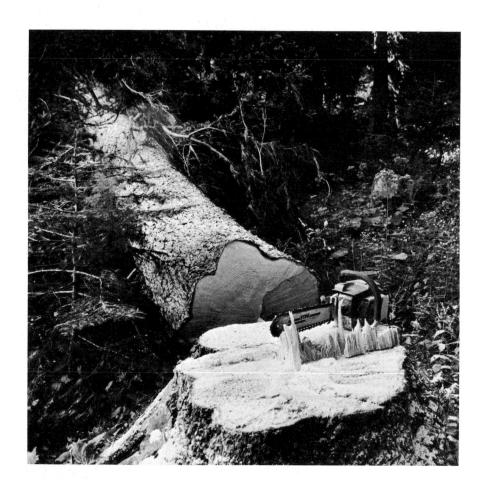

Gaston is paid by the cubic metre of wood he delivers to the edge of the road, where the lorries pick it up.

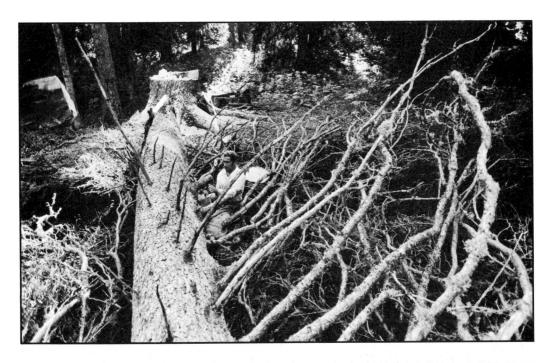

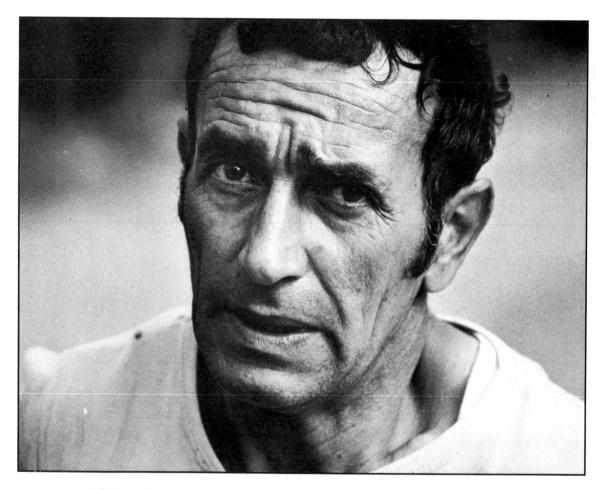

This is the portrait which Gaston's wife framed and put on their mantelpiece. There are no trees in it, but the expression of his face is easier to understand if one knows something about the forest.

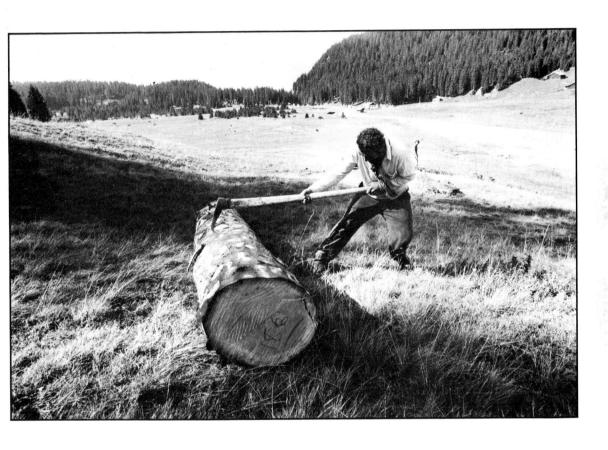

A DOUBTFUL EXORCISM

Java. December 1973. Djakarta — Bandung. A journey of 200 kilometres each way through ricefields and mountains. The organisation for which I was working had decided that taking a plane would be too expensive and too uncertain. To go by car would have meant finding not only a vehicle but a driver, for the roads were particularly dangerous. I was told to go by train.

And so I found myself in a comfortable Pullman, about to leave Djakarta. An art-student kindly offered me his seat by the window: "If one day I am travelling in Switzerland, I'm sure somebody will do the same for me, and I'll be able to enjoy in comfort Mont Cervin and the Jet d'Eau. You will see superb countryside soon, particularly when we get to the mountains."

However, before reaching this countryside we had to leave Djakarta, a fearful city of five million (the exact figures are uncertain and always changing). An endless suburb of the most squalid poverty — a monsoon-drenched poverty — sprawling either side of the railway line, often only a few inches from the tracks. The typical tragedy of a city smothered by the daily influx of peasants trying to live somewhere.

The sight of this, through the large Pullman window, was almost unbearable. Around me the other passengers chattered or read or day-dreamed. I was the only one who could not look away.

Soon the hills became higher, and the railway track began to wind in and out, and go through tunnels. Emerging from one of these tunnels, the train slowed down as if it were going to stop. It never stopped altogether, but it went very slowly for several kilometres. From every side children began to appear, half-naked, wild-eyed, hands outstretched. They ran along beside the train for several hundred metres before giving up. Nobody in the carriage noticed: even the art student kept his eyes on his book and gave me no explanation.

During my two days in Bandung, these children haunted me. On the return journey, once again with a place by the window, I had a camera ready: how do you free yourself from an obsession, when you are a photographer, if not by photographing the object of the obsession? And so, at a five-hundredth of a second, hidden behind my camera, I saw again those emaciated children running barefoot the length of the train, receiving nothing. Neither from the others, nor from me.

NO SCOOP

Many years ago I was travelling across Yugoslavia in a small 2cv. Citroen. I took my time, happy to be discovering so much that was new to me. There were few Western tourists then, for Yugoslavia was labelled "communist" in the Western press.

On my way to Belgrade I heard that a meeting was about to take place—the first—between Tito and Gomulka. Along with other press photographers from *Life*, *Paris-Match*, *Stern*, I took some pictures of this meeting.

Before leaving for Yugoslavia I had made an arrangement with a press agency whereby, should I come across any news story, I would send them back pictures. This was undoubtedly such a story, and so I sent the pictures by air back to Geneva. There were enough for a front page or a double-spread. Having dispatched them, I continued my slow, fascinating journey.

When finally I arrived home, I didn't expect to be congratulated—there is no such thing as congratulation in the world of photo agencies—but I did expect to find a little money in payment for my published pictures. I was quickly disabused.

"We could scarcely use a picture. You chose to show Tito as a head of state looking human, even friendly. Yet Tito is a communist, and the newspaper editors here, who buy our pictures, have a very clear idea of what a communist head of state looks like. They must have scowling and threatening faces. You should have thought of that, you know."

Ten years later, Tito began to be labelled "socialist" rather than "communist" in the Western press, and even to be lauded as the legendary figure who dared to oppose Moscow. My photographs of him then became useable.

THE SUBJECT NOT PHOTOGRAPHED

"To take or not to take?" This is a constant question for the photographer who is a reporter, walking along a street. The reasons for deciding not to take a picture are various.

Fear sometimes. You feel the possibility of violent reactions on the part of the photographed. In the dock areas of certain cities, for example. In Africa or South America a white photographer may draw upon himself all the hatred of that imperialism of which he has become, while taking pictures, the symbol.

Sometimes an ethical hesitation. To take a picture of an execution, for example — unless, with the picture, one intends to denounce the opressive regime.

There are many reasons for not taking pictures. But if you are a press photographer your employers will recognise none as valid.

Several years ago I made an expedition in the Alps with the aim of climbing the southern face of the Grandes Jorasses. That's the easier face. When we arrived at the hut where we were going to spend the night, we found another group of climbers who had just come down the northern face and who had been forced by a storm to spend the whole night a few metres from the summit. Several of them were suffering from severe frost bite. Their faces were haggard from the ordeal. The exclusive photos were there to be taken for the next day's papers.

I didn't even take out my camera. There was no virtue in this decision, there was simply something more urgent to be done: to take down the injured on our backs. (In those days there were no helicopters.)

Recently I was in hospital for two weeks following a back operation (that damned shoulder-bag of cameras and lenses and films that we all carry!). I lay on my back, motionless, not allowed to move. I began to

think photographs: the size of the ward, my unfortunate fellow patients (I was in the neurosurgical section for the skull and spinal column), the spotlessly clean corridors, the spotless ceiling, everywhere a white, spotless anguish. Photos could show this. And then I realised that you can't truly be on both sides of the fence at the same time. During many years, while working for the World Health Organisation, I'd taken pictures of the ill, the post-operative, the hurt. This time it was better to live totally on their side, so that the experience should be indelibly printed, not on film, but in my memory.

Appearances

by John Berger

This essay, although it appears under my name and is the culmination of many years' thinking about photography, nevertheless owes a great deal to the criticisms and encouragement of Gilles Aillaud, Anthony Barnett, Nella Bielski, Peter Fuller, Gérard Mordillat, Nicolas Philibert, Lloyd Spencer.

'Reason respects the differences and imagination the similitude of things.' Shelley

Nearly twenty years ago I had the project of taking a series of photographs which would accompany, and be interchangeable with, a sequence of love poems. Just as it was not clear whether the poems spoke with the voice of a woman or a man, so it should remain uncertain whether the image inspired the text or vice versa. My first interest in photography was passionate.

To learn how to use a camera, in order to be able to take these photographs, I went to see Jean Mohr. Alain Tanner gave me his address. Jean instructed me with great patience. And for two years I took hundreds of photographs in the hope of telling my love.

This is how my close interest in photography began. And I recall it now because, however theoretical and distanced some of my later remarks may appear to be, photography is still, first and foremost for me a means of expression. The all-important question is: What kind of means?

Jean Mohr and I became friends and then collaborators. This is the fourth book we have made together. During this collaboration we have continually tried to examine its nature. How should a photographer and writer collaborate? What are the possible relations between images and text? How can we approach the reader together? These questions did not arise abstractly, they imposed themselves whilst we were working on books which we believed to be urgent. The implications of a certain relationship between doctor and patient, between cure and suffering. The state of the visual arts in the Soviet Union. The experience of

migrant workers. And now, in this book, the way peasants look at themselves.

Faced with the problem of communicating experience, through a constant process of trial and error, we found ourselves having to doubt or reject many of the assumptions usually made about photography. We discovered that photographs did not work as we had been taught.

The ambiguity of the photograph

What makes photography a strange invention — with unforeseeable consequences — is that its primary raw materials are light and time.

Yet let us begin with something more tangible. A few days ago a friend of mine found this photograph and showed it to me.

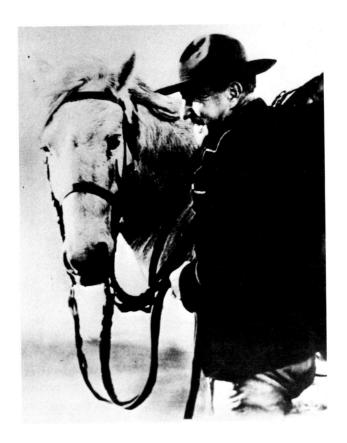

I know nothing about it. The best way of dating it is probably by its photographic technique. Between 1900 and 1920? I do not know whether it was taken in Canada, the Alps, South Africa. All one can see is that it shows a smiling middle-aged man with his horse. Why was it taken? What meaning did it have for the photographer? Would it have had the same meaning for the man with the horse?

One can play a game of inventing meanings. The Last Mountie. (His smile becomes nostalgic.) The Man Who Set Fire to Farms. (His smile becomes sinister.) Before the Trek of Two Thousand Miles. (His smile becomes a little apprehensive.) After the Trek of Two Thousand Miles. (His smile becomes modest.)...

The most definite information this photograph gives is about the type of bridle the horse is wearing, and this is certainly not the reason why it was taken. Looking at the photograph alone it is even hard to know to what use category it belonged. Was it a family-album picture, a newspaper picture, a traveller's snap?

Could it have been taken, not for the sake of the man, but of the horse? Was the man acting as a groom, just holding the horse? Was he a horse-dealer? Or was it a still photograph taken during the filming of one of the early Westerns?

The photograph offers irrefutable evidence that this man, this horse and this bridle existed. Yet it tells us nothing of the significance of their existence.

A photograph arrests the flow of time in which the event photographed once existed. All photographs are of the past, yet in them an instant of the past is arrested so that, unlike a lived past, it can never lead to the present. Every photograph presents us with two messages: a message concerning the event photographed and another concerning a shock of discontinuity.

Between the moment recorded and the present moment of looking at the photograph, there is an abyss. We are so used to photography that we no longer consciously register the second of these twin messages — except in special circumstances: when for example, the person photographed was familiar to us and is now far away or dead. In such circumstances the photograph is more traumatic than most memories or mementos because it seems to confirm, prophetically, the later discontinuity created by the absence or death. Imagine for a moment that you were once in love with the man with the horse and that he has now disappeared.

If, however, he is a total stranger, one thinks only of the first message, which here is so ambiguous that the event escapes one. What the photograph shows goes with any story one chooses to invent.

Nevertheless the mystery of this photograph does not quite end there. No invented story, no explanation offered will be quite as *present* as the banal appearances preserved in this photograph. These appearances may tell us very little, but they are unquestionable.

The first photographs were thought of as marvels because, far more directly than any other form of visual image, they presented the appearance of what was absent. They preserved the look of things and they allowed the look of things to be carried away. The marvel in this was not only technical.

Our response to appearances is a very deep one, and it includes elements which are instinctive and atavistic. For example, appearances alone — regardless of all conscious considerations — can sexually arouse. For example, the stimulus to action — however tentative it remains — can be provoked by the colour red. More widely, the look of the world is the widest possible confirmation of the *thereness* of the world, and thus the look of the world continually proposes and confirms

our relation to that thereness, which nourishes our sense of Being.

Before you tried to read the photograph of the man with the horse, before you placed it or named it, the simple act of looking at it confirmed, however briefly, your sense of being in the world, with its men, hats, horses, bridles . . .

*.

The ambiguity of a photograph does not reside within the instant of the event photographed: there the photographic evidence is less ambiguous than any eye-witness account. The photo-finish of a race is

rightly decided by what the camera has recorded. The ambiguity arises out of that discontinuity which gives rise to the second of the photograph's twin messages. (The abyss between the moment recorded and the moment of looking.)

A photograph preserves a moment of time and prevents it being effaced by the supersession of further moments. In this respect photographs might be compared to images stored in the memory. Yet there is a fundamental difference: whereas remembered images are the *residue* of continuous experience, a photograph isolates the appearances of a disconnected instant.

And in life, meaning is not instantaneous. Meaning is discovered in what connects, and cannot exist without development. Without a story, without an unfolding, there is no meaning. Facts, information, do not in themselves constitute meaning. Facts can be fed into a computer and become factors in a calculation. No meaning, however, comes out of computers, for when we give meaning to an event, that meaning is a response, not only to the known, but also to the unknown: meaning and mystery are inseparable, and neither can exist without the passing of time. Certainty may be instantaneous; doubt requires duration; meaning is born of the two. An instant photographed can only acquire meaning insofar as the viewer can read into it a duration extending beyond itself. When we find a photograph meaningful, we are lending it a past and a future.

The professional photographer tries, when taking a photograph, to choose an instant which will persuade the public viewer to lend it an *appropriate* past and future. The photographer's intelligence or his empathy with the subject defines for him what is appropriate. Yet unlike the story-teller or painter or actor, the photographer only makes, in any one photograph, *a single constitutive choice*: the choice of the instant to

be photographed. The photograph, compared with other means of communication, is therefore weak in intentionality.

A dramatic photograph may be as ambiguous as an undramatic one.

What is happening? It requires a caption for us to understand the significance of the event. "Nazis Burning Books". And the significance of the caption again depends upon a sense of history that we cannot necessarily take for granted.

All photographs are ambiguous. All photographs have been taken out of a continuity. If the event is a public event, this continuity is history; if it is personal, the continuity, which has been broken, is a life story. Even a pure landscape breaks a continuity: that of the light and the weather. Discontinuity always produces ambiguity. Yet often this ambiguity is not obvious, for as soon as photographs are used with words, they produce together an effect of certainty, even of dogmatic assertion.

In the relation between a photograph and words, the photograph begs for an interpretation, and the words usually supply it. The photograph, irrefutable as evidence but weak in meaning, is given a meaning by the words. And the words, which by themselves remain at the level of generalisation, are given specific authenticity by the irrefutability of the photograph. Together the two then become very powerful; an open question appears to have been fully answered.

Yet it might be that the photographic ambiguity, if recognised and accepted as such, could offer to photography a unique means of expression. Could this ambiguity suggest another way of telling? This is a question I want to raise now and return to later.

* *

Cameras are boxes for transporting appearances. The principle by which cameras work has not changed since their invention. Light, from the object photographed, passes through a hole and falls on to a photographic plate or film. The latter, because of its chemical preparation, preserves these traces of light. From these traces, through other slightly more complicated chemical processes, prints are made. Technically, by the standards of our century, it is a simple process. Just as the historically comparable invention of the printing press was, in its time, simple. What is still not so simple is to grasp the nature of the appearances which the camera transports.

Are the appearances which a camera transports a construction, a man-made cultural artifact, or are they, like a footprint in the sand, a trace *naturally* left by something that has passed? The answer is, both.

The photographer chooses the event he photographs. This choice can be thought of as a cultural construction. The space for this construction is, as it were, cleared by his rejection of what he did not choose to photograph. The construction is his reading of the event which is in front of his eyes. It is this reading, often intuitive and very fast, which decides his choice of the instant to be photographed.

Likewise, the photographed image of the event, when shown as a photograph, is also part of a cultural construction. It belongs to a specific social situation, the life of the photographer, an argument, an experiment, a way of explaining the world, a book, a newspaper, an exhibition.

Yet at the same time, the material relation between the image and what it represents (between the marks on the printing paper and the tree these marks represent) is an immediate and unconstructed one. And is indeed like a *trace*.

The photographer chooses the tree, the view of it he wants, the kind of film, the focus, the filter, the time-exposure, the strength of the developing solution, the sort of paper to print on, the darkness or lightness of the print, the framing of the print — all this and more. But where he does not intervene — and cannot intervene without changing the fundamental character of photography — is between the light, emanating from that tree as it passes through the lens, and the imprint it makes on the film.

It may clarify what we mean by a *trace* if we ask how a drawing differs from a photograph. A drawing is a translation. That is to say each mark on the paper is consciously related, not only to the real or imagined "model", but also to every mark and space already set out on the paper. Thus a drawn or painted image is woven together by the energy (or the lassitude, when the drawing is weak) of countless judgements. Every time a figuration is evoked in a drawing, everything about it has been mediated by consciousness, either intuitively or systematically. In a drawing an apple is *made* round and spherical; in a photograph, the

roundness and the light and shade of the apple are received as a given.

This difference between making and receiving also implies a very different relation to time. A drawing contains the time of its own making, and this means that it possesses its own time, independent of the living time of what it portrays. The photograph, by contrast, receives almost instantaneously — usually today at a speed which cannot be perceived by the human eye. The only time contained in a photograph is the isolated instant of what it shows.

There is another important difference within the times contained by the two kinds of images. The time which exists within a drawing is not uniform. The artist gives more time to what she or he considers important. A face is likely to contain more time than the sky above it. Time in a drawing accrues according to human value. In a photograph time is uniform: every part of the image has been subjected to a chemical process of uniform duration. In the process of revelation all parts were equal.

These differences between a drawing and a photograph relating to time lead us to the most fundamental distinction between the two means of communication. The countless judgements and decisions which constitute a drawing are systematic. That is to say that they are grounded in an existent language. The teaching of this language and its specific usages at any given time are historically variable. A master-painter's apprentice during the Renaissance learnt a different practice and grammar of drawing from a Chinese apprentice during the Sung period. But every drawing, in order to re-create appearances, has recourse to a language.

Photography, unlike drawing, does not possess a language. The photographic image is produced instantaneously by the reflection of light; its figuration is *not* impregnated by experience or consciousness.

Barthes, writing about photography, talked of "humanity encountering for the first time in its history *messages without a code*. Hence the photograph is not the last (improved) term of the great family of images; it corresponds to a decisive mutation of informational economics."† The mutation being that photographs supply information without having a language of their own.

Photographs do not translate from appearances. They quote from them.

* *

It is because photography has no language of its own, because it quotes rather than translates, that it is said that the camera cannot lie. It cannot lie because it prints directly.

(The fact that there were and are faked photographs is, paradoxically, a proof of this. You can only make a photograph tell an explicit lie by elaborate tampering, collage, and re-photographing. You have in fact ceased to practise photography. Photography in itself has no language which can be *turned*.) And yet photographs can be, and are, massively used to deceive and misinform.

We are surrounded by photographic images which constitute a global system of misinformation: the system known as publicity, proliferating consumerist lies. The role of photography in this system is revealing. The lie is constructed before the camera. A "tableau" of objects and figures is assembled. This "tableau" uses a language of symbols (often inherited, as I have pointed out elsewhere,* from the iconography of oil painting), an implied narrative and, frequently, some kind of performance by models with a sexual content. This "tableau" is then photographed. It is photographed precisely because the camera can bestow

^{*}John Berger, Ways of Seeing (London: British Broadcasting Corporation and Penguin Books Ltd, 1972), pp. 134. 141.

[†]Roland Barthes, Image-Music-Text (London: Fontana, 1977), p.45.

authenticity upon any set of appearances, however false. The camera does not lie even when it is used to quote a lie. And so, this makes the lie *appear* more truthful.

The photographic quotation is, within its limits, incontrovertible. Yet the quotation, placed like a fact in an explicit or implicit argument, can misinform. Sometimes the misinforming is deliberate, as in the case of publicity; often it is the result of an unquestioned ideological assumption.

For example, all over the world during the nineteenth century, European travellers, soldiers, colonial administrators, adventurers, took photographs of "the natives", their customs, their architecture, their richness, their poverty, their women's breasts, their headdresses; and these images, besides provoking amazement, were presented and read as proof of the justice of the imperial division of the world. The division between those who organised and rationalised and surveyed, and those who *were* surveyed.

In itself the photograph cannot lie, but, by the same token, it cannot tell the truth; or rather, the truth it does tell, the truth it can by itself defend, is a limited one.

The idealistic early press photographers — in the twenties and thirties of this century — believed that their mission was to bring home the truth to the world.

Sometimes I come away from what I am photographing sick at heart, with the faces of people in pain etched as sharply in my mind as on my negatives. But I go back because I feel it is my place to make such pictures. Utter truth is essential, and that is what stirs me when I look through the camera.

Margaret Bourke-White

I admire the work of Margaret Bourke-White. And photographers, under certain political circumstances, have indeed helped to alert public opinion to the truth of what was happening elsewhere. For example: the degree of rural poverty in the United States in the 1930s; the treatment of Jews in the streets of Nazi Germany; the effects of US napalm bombing in Vietnam. Yet to believe that what one sees, as one looks through a camera on to the experience of others, is the "utter truth" risks confusing very different levels of the truth. And this confusion is endemic to the present public use of photographs.

Photographs are used for scientific investigation: in medicine, physics, meteorology, astronomy, biology. Photographic information is also fed into systems of social and political control — dossiers, passports, military intelligence. Other photographs are used in the media as a means of public communication. The three contexts are different, and yet it has been generally assumed that the truthfulness of the photograph — or the way that this truth functions — is the same in all three.

In fact, when a photograph is used scientifically, its unquestionable evidence is an aid in coming to a conclusion: it supplies information within the conceptual framework of an investigation. It supplies a missing detail. When photographs are used in a control system, their evidence is more or less limited to establishing identity and presence. But as soon as a photograph is used as a means of communication, the nature of lived experience is involved, and then the truth becomes more complex.

An X-ray photograph of a wounded leg can tell the "utter truth" about whether the bones are fractured or not. But how does a photograph tell the "utter truth" about a man's experience of hunger or, for that matter, his experience of a feast?

At one level there are no photographs which can be denied. All photographs have the status of fact. What has to be examined is in what way photography can and cannot give meaning to facts.

* *

Let us recall how and when photography was born, how, as it were, it was christened, and how it grew up.

The camera was invented in 1839. Auguste Comte was just finishing his *Cours de Philosophie Positive*. Positivism and the camera and sociology grew up together. What sustained them all as practices was the belief that observable quantifiable facts, recorded by scientists and experts, would one day offer man such a total knowledge about nature and society that he would be able to order them both. Precision would replace metaphysics, planning would resolve social conflicts, truth would replace subjectivity, and all that was dark and hidden in the soul would be illuminated by empirical knowledge. Comte wrote that theoretically nothing need remain unknown to man except, perhaps, the origin of the stars! Since then cameras have photographed even the formation of stars! And photographers now supply us with more facts every month than the eighteenth century Encylopaedists dreamt of in their whole project.

Yet the positivist utopia was not achieved. And the world today is less controllable by experts, who have mastered what they believe to be its mechanisms, than it was in the nineteenth century.

What was achieved was unprecedented scientific and technical progress and, eventually, the subordination of all other values to those of a world market which treats everything, including people and their labour and their lives and their deaths, as a commodity. The unachieved positivist utopia became, instead, the global system of late capitalism wherein all that exists becomes quantifiable — not simply because it can be reduced to a statistical fact, but also because it has been reduced to a commodity.

In such a system there is no space for experience. Each person's experience remains an individual problem. Personal psychology replaces philosophy as an explanation of the world.

Nor is there space for the social function of subjectivity. All subjectivity is treated as private, and the only (false) form of it which is socially allowed is that of the individual consumer's dream.

From this primary suppression of the social function of subjectivity, other suppressions follow: of meaningful democracy (replaced by opinion polls and market-research techniques), of social conscience (replaced by self-interest), of history (replaced by racist and other myths), of hope — the most subjective and social of all energies (replaced by the sacralisation of Progress as Comfort).

The way photography is used today both derives from and confirms the suppression of the social function of subjectivity. Photographs, it is said, tell the truth. From this simplification, which reduces the truth to the instantaneous, it follows that what a photograph tells about a door or a volcano belongs to the same order of truth as what it tells about a man weeping or a woman's body.

If no theoretical distinction has been made between the photograph as scientific evidence and the photograph as a means of communication, this has been not so much an oversight as a proposal.

The proposal was (and is) that when something is visible, it is a fact, and that facts contain the only truth.

Public photography has remained the child of the hopes of positivism. Orphaned — because these hopes are now dead — it has been adopted by the opportunism of corporate capitalism. It seems likely that the denial of the innate ambiguity of the photograph is closely connected with the denial of the social function of subjectivity.

A popular use of photography

'In our age there is no work of art that is looked at so closely as a photograph of oneself, one's closest relatives and friends, one's sweetheart,' wrote Lichtwark back in 1907, thereby moving the inquiry out of the realm of aesthetic distinctions into that of social functions. Only now this vantage point can be carried further.'

Walter Benjamin, A Small History of Photography (1931).

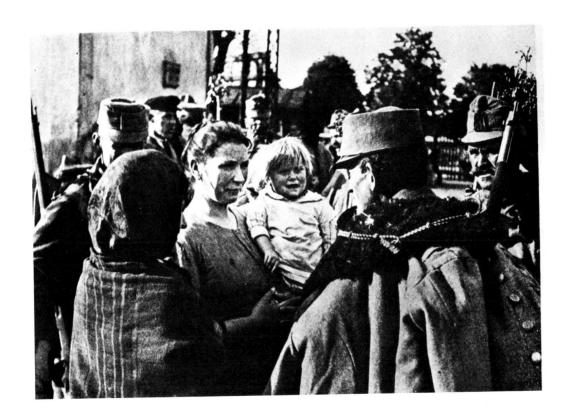

A mother with her child is staring intently at a soldier. Perhaps they are speaking. We cannot hear their words. Perhaps they are saying nothing and everything is being said by the way they are looking at each other. Certainly a drama is being enacted between them.

The caption reads: "A Red Hussar Leaving, June 1919, Budapest." The photograph is by André Kertesz.

So, the woman has just walked out of their home and will shortly go back alone with the child. The drama of the moment is expressed in the difference between the clothes they are wearing. His for travelling, for sleeping out, for fighting; hers for staying at home.

The caption can also entail other thoughts. The Hapsburg monarchy had fallen the previous autumn. The winter had been one of extreme shortages (especially of fuel in Budapest) and economic distintegration. Two months before, in March, the socialist Republic of Councils had been declared. The Western allies in Paris, fearful lest the Russian and now the Hungarian example of revolution should spread throughout Eastern Europe and the Balkans, were planning to dismantle the new republic. A blockade was already imposed. General Foch himself was planning the military invasion being carried out by Rumanian and Czech troops. On June 8th Clemenceau telegraphed an ultimatum to Béla Kun demanding a Hungarian military withdrawal which would have left the Rumanians occupying the eastern third of their country. For another six weeks the Hungarian Red Army fought on, but it was finally overwhelmed. By August, Budapest was occupied and very soon after, the first European fascist regime under Horthy was established.

If we are looking at an image from the past and we want to relate it to ourselves, we need to know something of the history of that past. And so the foregoing paragraph — and much more than that might be said — is relevant to the reading of Kertesz's photograph. Which is presumably

why he gave it the caption he did and not just the title "Parting". Yet the photograph — or rather, the way this photograph demands to be read—cannot be limited to the historical.

Everything in it is historical: the uniforms, the rifles, the corner by the Budapest railway station, the identity and biographies of all the people who are (or were) recognisable — even the size of the trees on the other side of the fence. And yet it also concerns a resistance to history: an opposition.

This opposition is not the consequence of the photographer having said Stop! It is not that the resultant static image is like a fixed post in a flowing river. We know that in a moment the soldier will turn his back and leave; we presume that he is the father of the child in the woman's arms. The significance of the instant photographed is already claiming minutes, weeks, years.

The opposition exists in the parting look between the man and the woman. This look is not directed towards the viewer. We witness it as the older soldier with the moustache and the woman with the shawl (perhaps a sister) do. The exclusivity of this look is further emphasised by the boy in the mother's arms; he is watching his father, and yet he is excluded from their look.

This look, which crosses before our eyes, is holding in place what *is*, not specifically what is there around them outside the station, but what *is* their life, what *are* their lives. The woman and the soldier are looking at each other so that the image of what *is* now shall remain for them. In this look their being *is* opposed to their history, even if we assume that this history is one they accept or have chosen.

How can one be opposed to history? Conservatives may oppose with force changes in history. But there is another kind of opposition. Who can read Marx and not feel his hatred towards the historical processes he discovered and his impatience for the end of history when, he believed, the realm of necessity would be transformed into the realm of freedom?

An opposition to history may be partly an opposition to what happens in it. But not only that. Every revolutionary protest is also a project against people being the objects of history. And as soon as people feel, as the result of their desperate protest, that they are no longer such objects, history ceases to have the monopoly of time.

Imagine the blade of a giant guillotine as long as the diameter of the city. Imagine the blade descending and cutting a section through everything that is there — walls, railway lines, wagons, workshops, churches, crates of fruit, trees, sky, cobblestones. Such a blade has fallen a few yards in front of the face of everyone who is determined to fight. Each finds himself a few yards from the precipitous edge of an infinitely deep fissure which only he can see. The fissure, like a deep cut into the flesh, is unmistakably itself; there can be no doubting what has happened. But there is no pain at first.

The pain is the thought of one's own death probably being very near. It occurs to the men and women building the barricades that what they are handling, and what they are thinking, are probably being handled and thought by them for the last time. As they build the defences, the pain increases.

. . . At the barricades the pain is over. The transformation is complete. It is completed by a shout from the rooftops that the soldiers are

advancing. Suddenly there is nothing to regret. The barricades are between their defenders and the violence done to them throughout their lives. There is nothing to regret because it is the quintessence of their past which is now advancing against them. On their side of the barricades it is already the future.*

Revolutionary actions are rare. Feelings of opposition to history, however, are constant, even if unarticulated. They often find their expression in what is called private life. A home has become not only a physical shelter but also a teleological shelter, however frail, against the remorselessness of history; a remorselessness which should be distinguished from the brutality, injustice and misery the same history often contains.

People's opposition to history is a reaction (even a protest, but a protest so intimate that it has no direct social expression and the indirect ones are often mystified and dangerous: both fascism and racism feed upon such protests) against a violence done to them. The violence consists in conflating time and history so that the two become indivisible, so that people can no longer read their experience of either of them separately.

This conflation began in Europe in the nineteenth century, and has become more complete and more extensive as the rate of historical change has increased and become global. All popular religious movements — such as the present mounting Islamic one against the materialism of the West — are a form of resistance to the violence of this conflation.

What does this violence consist in? The human imagination which grasps and unifies time (before imagination existed, each time scale—cosmic, geological, biological—was disparate) has always had the

^{*}John Berger, G. (London: Weidenfeld & Nicolson, 1972), pp.71-72.

capacity of undoing time. This capacity is closely connected with the faculty of memory. Yet time is undone not only by being remembered but also by the living of certain moments which defy the passing of time, not so much by becoming unforgettable but because, within the experience of such moments there is an imperviousness to time. They are experiences which provoke the words *for ever, toujours, siempre, immer.* Moments of achievement, trance, dream, passion, crucial ethical decision, prowess, near-death, sacrifice, mourning, music, the visitation of *duende*. To name some of them.

Such moments have continually occurred in human experience. Although not frequent in any one lifetime, they are common. They are the material of *all* lyrical expression (from pop music to Heine and Sappho). Nobody has lived without experiencing such moments. Where people differ is in the confidence with which they credit importance to them. I say confidence since I believe that intimately, if not publicly, no one fails to allow them some importance. They are summit moments and they are intrinsic to the relation imagination/time.

Before time and history were conflated, the rate of historical change was slow enough for an individual's awareness of time passing to remain quite distinct from her or his awareness of historical change. The sequences of an individual life were surrounded by the relatively changeless, and the relatively changeless (history) was in its turn surrounded by the timeless.

History used to pay its respects to mortality: the enduring honoured the value of what was brief. Graves were a mark of such respect. Moments which defied time in the individual life were like glimpses through a window; these windows, let into the life, looked *across* history, which changed slowly, towards the timeless which would never change.

When in the eighteenth century the rate of historical change began to accelerate, causing the principle of historical progress to be born, the timeless or unchanging was claimed by and gradually incorporated into historical time. Astronomy arranged the stars historically. Renan historicised Christianity. Darwin made every origin historical. Meanwhile, actively, through imperialism and proletarianisation, other cultures and ways of life and work, which embodied different traditions concerning time, were being destroyed. The factory which works all night is a sign of the victory of a ceaseless, uniform and remorseless time. The factory continues even during the time of dreams.

The principle of historical progress insisted that the elimination of all other views of history save its own was part of that progress. Superstition, embedded conservatism, so-called eternal laws, fatalism, social passivity, the fear of eternity so skilfully used by churches to intimidate, repetition and ignorance: all these had to be swept away and replaced by the proposal that man could make his own history. And indeed this did — and does — represent progress, in that social justice cannot be fully achieved without such an awareness of the historical possibility, and this awareness depends upon historical explanations being given.

Nevertheless a deep violence was done to subjective experience. And to argue that this is unimportant in comparison with the objective historical possibilities created is to miss the point because, precisely, the modern anguished form of the distinction subjective/objective begins and develops with this violence.

Today what surrounds the individual life can change more quickly than the brief sequences of that life itself. The timeless has been abolished, and history itself has become ephemerality. History no longer pays its respects to the dead: the dead are simply what it has passed through. (A study of the comparative number of public

monuments erected during the last hundred years in the West would show a startling decline during the last twenty-five.) There is no longer any generally acknowledged value longer than that of a life, and most are shorter. The worldwide phenomenon of inflation is symptomatic in this respect: an unprecedented modern form of economic transience.

Consequently the common experience of those moments which defy time is now denied by everything which surrounds them. Such moments have ceased to be like windows looking across history towards the timeless. Experiences which prompt the term *for ever* have now to be assumed alone and privately. Their role has been changed: instead of transcending, they isolate. The period in which photography has developed corresponds to the period in which this uniquely modern anguish has become commonplace.

Yet fortunately people are never only the passive objects of history. And apart from popular heroism, there is also popular ingenuity. In this case such ingenuity uses whatever little there is at hand, to preserve experience, to re-create an area of "timelessness", to insist upon the permanent. And so, hundreds of millions of photographs, fragile images, often carried next to the heart or placed by the side of the bed, are used to refer to that which historical time has no right to destroy.

The private photograph is treated and valued today as if it were the materialisation of that glimpse through the window which looked across history towards that which was outside time.

**

The photograph of the woman and the red hussar represents an idea. The idea was not Kertesz's. It was being lived in front of his eyes and he was receptive to it.

What did he see?

Summer sunlight.

The contrast between her dress and the heavy greatcoats of the soldiers who will have to sleep out.

The men waiting with a certain heaviness.

Her concentration — she looks at him as if already into the distance which will claim him.

Her scowl, which will not give way to weeping.

His modesty — one reads it by his ear and the way he holds his head — because at this moment she is stronger than he.

Her acceptance, in the stance of her body.

The boy, surprised by the father's uniform, aware of the unusual occasion.

Her hair arranged before coming out, her worn dress.

The limits of their wardrobe.

It is only possible to itemise the things seen, for if they touch the heart, they do so essentially through the eye. For example, the appearance of the woman's hands clasped over her stomach tells how she might peel potatoes, how one of her hands might lie when asleep, how she would put up her hair.

The woman and the soldier are recognising one another. How close a parting is to a meeting! And through that act of recognition, such as perhaps they have never experienced before, each hopes to take away an image of the other which will withstand anything that may happen. An image that nothing can efface. This is the idea being lived before Kertesz's camera. And this is what makes this photograph paradigmatic. It shows a moment which is explicitly about what is implicit in all photographs that are not simply enjoyed but loved.

All photographs are possible contributions to history, and any photograph, under certain circumstances, can be used in order to break the monopoly which history today has over time.

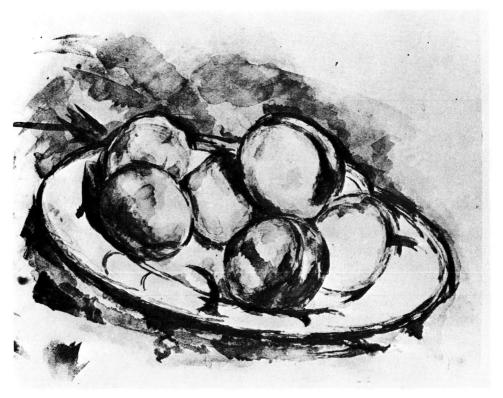

Pêches sur une assiette, Cézanne

The enigma of appearances

To read what has never been written.

- Hofmannsthal

We have looked at two different uses of photography. An ideological use, which treats the positivist evidence of a photograph as if it represented the ultimate and only truth. And in contrast, a popular but private use which cherishes a photograph to substantiate a subjective feeling.

I have not considered photography as an art. Paul Strand, who was a great photographer, thought of himself as an artist. In recent years art museums have begun to collect and show photographs. Man Ray said: "I photograph what I do not wish to paint, and I paint what I cannot photograph." Other equally serious photographers, like Bruce Davidson, claim it as a virtue that their pictures do not "pose as art".

The arguments, put forward from the nineteenth century onwards, about photography sometimes being an art have confused rather than clarified the issue because they have always led to some kind of comparison with the art of painting. And an art of translation cannot usefully be compared to an art of quotation. Their resemblances, their influence one upon the other, are purely formal; functionally they have nothing in common.

Yet however true this may be, a crucial question remains: why can photographs of unknown subjects move us? If photographs do not function like paintings, how do they function? I have argued that photographs quote from appearances. This may suggest that appearances themselves constitute a language.

What sense does it make to say this?

Let me first try to avoid a possible misunderstanding. In his last book

Barthes wrote: "Each time when having gone a little way with a language, I have felt that its system consists in, and in that way is slipping towards, a kind of reductionism and disapproval, I have quietly left and looked elsewhere."*

Unlike their late master, some of Barthes' structuralist followers love closed systems. They would maintain that in my reading of Kertesz's photograph, I relied upon a number of semiological systems, each one being a social/cultural construct: the sign-language of clothes, of facial expressions, of bodily gestures, of social manners, of photographic framing, etc. Such semiological systems do indeed exist and are continually being used in the making and reading of images. Nevertheless the sum total of these systems cannot exhaust, does not begin to cover, all that can be read in appearances. Barthes himself was of this opinion. The problem of appearances constituting something like a language cannot be resolved simply by reference to these semiological systems.

So we are left with the question: what sense does it make to say that appearances may constitute a language?

Appearances cohere. At the first degree they cohere because of common laws of structure and growth which establish visual affinities. A chip of rock can resemble a mountain; grass grows like hair; waves have the form of valleys; snow is crystalline; the growth of walnuts is constrained in their shells somewhat like the growth of brains in their skulls; all supporting legs and feet, whether static or mobile, visually refer to one another; etc., etc.

At the second degree, appearances cohere because as soon as a fairly developed eye exists, visual imitation begins. All natural camouflage, much natural colouring and a wide range of animal behaviour derive from the principle of appearances fusing or being suggestive of other appearances. On the underside of the wings of the Brassolinae, there are markings which imitate, with great accuracy, the eyes of an owl or

^{*}Roland Barthes, Reflections on Photography (New York: Farrar, Strauss & Giroux, 1981).

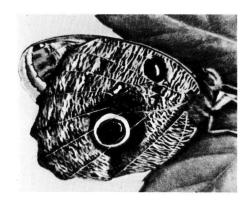

another large bird. When attacked, these butterflies flick their wings and their attackers are intimidated by the flashing eyes.

Appearances both distinguish and join events.

During the second half of the nineteenth century, when the coherence of appearances had been largely forgotten, one man understood and insisted upon the significance of such a coherence. "Objects interpenetrate each other. They never cease to live. Imperceptibly they spread intimate reflections around them." Cézanne.

Appearances also cohere within the mind as perceptions. The sight of any single thing or event entrains the sight of other things and events. To recognise an appearance requires the memory of other appearances. And these memories, often projected as expectations, continue to qualify the seen long after the stage of primary recognition. Here for

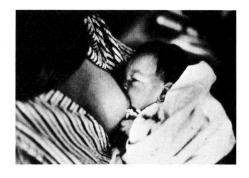

example, we recognise a baby at the breast, but neither our visual memory nor our visual expectations stop there. One image interpenetrates another.

As soon as we say that appearances *cohere* this *coherence* proposes a unity not unlike that of a language.

* *

Seeing and organic life are both dependent upon light, and appearances are the face of this mutuality. And so appearances can be said to be doubly systematic. They belong to a natural affinitive system which exists as such because of certain universal structural and dynamic laws. This is why, as already noted, all legs resemble one another. Secondly, they belong to a perceptive system which organises the mind's experience of the visible.

The primary energy of the first system is natural reproduction, always thrusting towards the future; the primary energy of the second system is memory, continually retaining the past. In all perceived appearances there is the double traffic of both systems.

We now know that it is the right hemisphere of the human brain which "reads" and stores our visual experience. This is significant because the areas and centres where this takes place are structurally identical with those in the left hemisphere which process our experience of words. The apparatus with which we deal with appearances is identical with that with which we deal with verbal language. Furthermore, appearances in their unmediated state — that is to say, before they have been interpreted or perceived — lend themselves to reference systems (so that they may be stored at a certain level in the memory) which are comparable to those used for words. And this again prompts one to conclude

that appearances possess some of the qualities of a code.

All cultures previous to our own treated appearances as signs addressed to the living. All was *legend*: all was there to be *read* by the eye. Appearances revealed resemblances, analogies, sympathies, antipathies, and each of these conveyed a message. The sum total of these messages explained the universe.

The Cartesian revolution overthrew the basis for any such explanation. It was no longer the relation between the look of things which mattered. What mattered was measurement and difference, rather than visual correspondences. The purely physical could no longer in itself reveal meaning, it could do so only if investigated by reason, which was the probe of the spiritual. Appearances ceased to be double-faced like the words of a dialogue. They became dense and opaque, requiring dissection.

Modern science became possible. The visible, however, deprived of any ontological function, was philosophically reduced to the area of aesthetics. Aesthetics was the study of sensuous perceptions as they affected an individual's feelings. Thus, the reading of appearances became fragmented; they were no longer treated as a signifying whole. Appearances were reduced to contingency, whose meaning was purely personal.

The development may help to explain the fitfulness and erratic history of nineteenth-century and twentieth-century visual art. For the first time ever, visual art was severed from the belief that it was in the very nature of appearances to be meaningful.

If, however, I persist in maintaining that appearances resemble a language, considerable difficulties arise. Where, for example, are its *universals*? A language of appearance implies an encoder; if appearances are there to be read, who wrote them?

It was a rationalist illusion to believe that in dispensing with religion, mysteries would be reduced. What has happened, on the contrary, is that mysteries multiply. Merleau-Ponty wrote:

We must take literally what vision teaches us, namely that through it we come in contact with the sun and the stars, that we are everywhere all at once, and that even our power to imagine ourselves elsewhere ... borrows from vision and employs means we owe to it. Vision alone makes us learn that beings that are different, "exterior", foreign to one another, are yet absolutely *together*, are "simultaneity"; this is a mystery psychologists handle the way a child handles explosives.*

There is no need to disinter ancient religious and magical beliefs which held that the visible is *nothing except a coded message*. These beliefs, being ahistorical, ignored the coincidence of the historical development of eye *and* brain. They also ignored the coincidence that both seeing and organic life are dependent upon light. Yet the enigma of appearances remains, whatever our historical explanations. Philosophically, we can evade the enigma. But we cannot *look* away from it.

* *

One looks at one's surroundings (and one is always surrounded by the visible, even in dreams) and one reads what is there, according to circumstances, in different ways. Driving a car draws out one kind of reading; cutting down a tree another; waiting for a friend another. Each activity motivates its own reading.

At other times the reading, or the choices which make a reading, instead of being directed towards a goal, are the consequence of an event that has already occurred. Emotion or mood motivates the

^{*}Maurice Merleau-Ponty, *The Primacy of Perception* (Evanston, Ill.: Northwestern University Press, 1964), p.187.

reading, and the appearances, thus read, become *expressive*. Such moments have often been described in literature, but they do not belong to literature, they belong to the visible.

Ghassan Kanafani, the Palestinian writer, describes a moment when everything he was looking at became expressive of the same pain and determination:

Never shall I forget Nadia's leg, amputated from the top of the thigh. No! Nor shall I forget the grief which had moulded her face and merged into its traits for ever. I went out of the hospital in Gaza that day, my hand clutched in silent derision on the two pounds I had brought with me to give Nadia. The blazing sun filled the streets with the colour of blood. And Gaza was brand new, Mustafa! You and I never saw it like this. The stones piled up at the beginning of the Shajiya quarter where we lived had a meaning, and they seemed to have been put there for no other reason but to explain it. This Gaza in which we had lived and with whose good people we had spent seven years of defeat was something new. It seemed to me just a beginning. I don't know why I thought it was just a beginning. I imagined that the main street that I walked along on the way back home was only the beginning of a long, long road leading to Safad. Everything in this Gaza throbbed with sadness which was not confined to weeping. It was a challenge; more than that, it was something like reclamation of the amputated leg.*

In every act of looking there is an expectation of meaning. This expectation should be distinguished from a desire for an explanation. The one who looks may explain *aftewards*; but, prior to any explanation, there is the expectation of what appearances themselves may be about to reveal.

^{*}G. Kanafani, Men in the Sun (London: Heinemann Educational Books, 1978), p.79.

Revelations do not usually come easily. Appearances are so complex that only the search which is inherent in the act of looking can draw a reading out of their underlying coherence. If, for the sake of a temporary clarification, one artificially separates appearances from vision (and we have seen that in fact this is impossible), one might say that in appearances everything that can be read is already there, but undifferentiated. It is the search, with its choices, which differentiates. And *the seen*, the revealed, is the child of both appearances and the search.

Another way of making this relation clearer would be to say that appearances in themselves are oracular. Like oracles they go beyond, they insinuate further than the discrete phenomena they present, and yet their insinuations are rarely sufficient to make any more comprehensive reading indisputable. The precise meaning of an oracular statement depends upon the quest or need of the one who listens to it. Everyone listens to an oracle alone, even when in company.

The one who looks is essential to the meaning found, and yet can be surpassed by it. And this surpassing is what is hoped for. Revelation was a visual category before it was a religious one. The hope of revelation—and this is particularly obvious in every childhood—is the stimulus to the will to all looking which does not have a precise functional aim.

Revelation, when what we see does surpass us, is perhaps less rare than is generally assumed. By its nature, revelation does not easily lend itself to verbalisation. The words used remain aesthetic exclamations! Yet whatever its frequency, our expectation of revelation is, I would suggest, a human constant. The form of this expectation may historically change, but in itself, it is a constituent of the relation between the human capacity to perceive and the coherence of appearances.

The totality of this relationship is perhaps best indicated by saying that

appearances constitute a half-language. Such a formulation, suggesting both a resemblance to and a difference from a full language, is both clumsy and imprecise, but at least it opens up a space for a number of ideas.

*.

The positivist view of photography has remained dominant, despite its inadequacies, because no other view is possible unless one comes to terms with the revelational nature of appearances. All the best photographers worked by intuition. In terms of their work, this lack of theory did not matter much. What did matter is that the photographic possibility remained theoretically hidden.

What is this possibility?

The single constitutive choice of a photographer differs from the continuous and more random choices of someone who is looking. Every photographer knows that a photograph simplifies. The simplifications concern focus, tonality, depth, framing, supersession (what is photographed does not change), texture, colour, scale, the other senses (their influence on sight is excluded), the play of light. A photograph quotes from appearances but, in quoting, simplifies them. This simplification can increase their legibility. Everything depends upon the quality of the quotation chosen.

The photograph of the man with the horse quotes very briefly. Kertesz's photograph outside Budapest railway station quotes at length.

The "length" of the quotation has nothing to do with exposure time. It is not a temporal length. Earlier we saw that a photographer, through the choice of the instant photographed, may try to persuade the viewer to lend that instant a past and a future. Looking at the man with the

horse, we have no clear idea of what has just happened or what is about to happen. Looking at the Kertesz, we can trace a story backwards for years and forwards for at least a few hours. This difference in the narrative range of the two images is important, yet although it may be closely associated with the "length" of the quotation, it does not in itself represent that length. It is necessary to repeat that the length of the quotation is in no sense a temporal length. It is not time that is prolonged but meaning.

The photograph cuts across time and discloses a cross-section of the event or events which were developing at that instant. We have seen that the instantaneous tends to make meaning ambiguous. But the cross-section, if it is wide enough, and can be studied at leisure, allows us to see the interconnectedness and related coexistence of events. Correspondences, which ultimately derive from the unity of appearances, then compensate for the lack of sequence.

This may become clearer if I express it in a diagrammatic, but necessarily highly schematic, way.

In life it is an event's development in time, its duration, which allows its meaning to be perceived and felt. If one states this actively, one can say that the event moves towards or through meaning. This movement can be represented by an arrow.

Normally a photograph arrests this movement and cuts across the appearances of the event photographed. Its meaning becomes ambiguous.

Only by the spectator's lending the frozen appearances a supposed past and future can the arrow's movement be hypothesised.

Above I represented the photographic cut by a vertical line. If, however, one thinks of this cut as a cross-section of the event, one can repre-

sent it frontally, as it were, instead of from the side, as a circle. One then has a diagram like this - - - - - - - - -

The diameter of the circle depends upon the amount of information to be found in the event's instantaneous appearances. The diameter (the amount of information received) may vary according to the spectator's personal relation to the photographed event. When the man with the horse is a stranger, the diameter remains small, the circle a very reduced one. When the same man is your son, the amount of information gleaned, and the diameter of the circle, increase dramatically.

The exceptional photograph which quotes at length increases the diameter of the circle even when the subject is totally unknown to the spectator.

This increase is achieved by the coherence of the appearances — as photographed at that precise conjuncture — extending the event beyond itself. The appearances of the event photographed implicate other events. It is the energy of these simultaneous connections and cross-references which enlarge the circle beyond the dimension of instantaneous information.

Thus, the discontinuity which is the result of the photographic cut is no longer destructive, for in the photograph of the long quotation another kind of meaning has become possible. The particular event photographed implicates other events by way of an idea born of the appearances of the first event. This idea cannot be merely tautologous. (An image of a person weeping and the idea of suffering would be tautologous.) The idea, confronting the event, extends and joins it to

other events, thus widening the diameter.

How is it possible for appearances to "give birth" to ideas? Through their specific coherence at a given instant, they articulate a set of *correspondences* which provoke in the viewer a recognition of some past experience. This recognition may remain at the level of a tacit agreement with memory, or it may become conscious. When this happens, it is formulated as an idea.

A photograph which achieves expressiveness thus works dialectically: it preserves the particularity of the event recorded, and it chooses an instant when the correspondences of those particular appearances articulate a general idea.

In his *Philosophy of Right**, Hegel defines individuality as follows:

Every self-consciousness knows itself (1) as universal, as the potentiality of abstracting from everything determinate, and (2) as particular, with a determinate object, content and aim. Still, both these moments are only abstractions; what is concrete and true (and everything true is concrete) is the universality which has the particular as its opposite, but the particular which by its reflection into itself has been equalised with the universal. This unity is individuality.

In every expressive photograph, in every photograph which quotes at length, the particular, by way of a general idea, has been *equalised with* the universal.

* *

A young man is asleep at the table in a public place, perhaps a café. The expression on his face, his character, the way the light and shade dissolve

^{*}Georg W. F. Hegel, *Philosophy of Right* (London: Oxford University Press, 1975), p.7.

Boy Sleeping, May 25, 1912, Budapest (André Kertesz)

him and his clothes, his open shirt and the newspaper on the table, his health and his fatigue, the time of night: all these are visually present in this event and are particular.

Emanating from the event and confronting it is the general idea. In this photograph the idea concerns legibility. Or, more precisely, the distinction, the stroke, between legibility/illegibility.

Remove the newspapers on the table and on the wall behind the sleeping figure, and the photograph will no longer be expressive — until or unless what replaces them instigates another idea.

The event instigates the idea. And the idea, confronting the event, urges it to go beyond itself and to represent the generalisation (what Hegel calls the abstraction) carried within the idea. We see a particular young man asleep. And seeing him, we ponder on sleep in general. Yet this pondering does not take us away from the particular; on the contrary, it has been instigated by it and everything we continue to read is in the interest of the particular. We think or feel or remember through the appearances recorded in the photograph, and with the idea of legibility/illegibility which was instigated by them.

The print of the newspaper the young man was reading before he fell asleep, the print of the newspapers hanging on the wall, which we can almost read even from this distance — all written news, all written regulations and time-tables — have for him become temporarily unreadable. And at the same time, what is going on in his sleeping mind, the way he is recovering from his fatigue, are unreadable for us, or for anybody else who was waiting in the waiting-room. Two legibilities. Two illegibilities. The idea of the photograph oscillates (like his breathing) between the two poles.

None of this was constructed or planned by Kertesz. His task was to be to that degree receptive to the coherence of appearances at that instant from that position in that place. The correspondences, which emerge

from this coherence, are too extensive and too interwoven to enumerate very satisfactorily in words. (One cannot take photographs with a dictionary.) Paper corresponds with cloth, with folds, with facial features, with print, with darkness, with sleep, with light, with legibility. In the quality of Kertesz's *receptivity* here, one sees how a photograph's lack of intentionality becomes its strength, its lucidity.

Friends, September 3, 1917, Esztergan (André Kertesz)

A young boy in 1917 playing in a field with a lamb. He is clearly aware of being photographed. He is both exuberant and innocent.

What makes this photograph memorable? Why does it provoke memories in us? We, who are not Hungarian shepherd boys born before the First World War. It is not memorable, as most picture-editors might assume, because the boy's expression and gestures are happy and charming. When isolated, photographed gestures and expressions become either mute or caricatural. Here, however, they are not isolated. They contain and are confronted by an idea.

What we see of the lamb — what makes the animal instantly recognisable as a lamb — is the texture of its fleece: that very texture which the boy's hand is stroking and which has attracted him to play with the animal in the way he is. Simultaneously with the texture of the fleece, we notice — or the photograph insists that we notice — the texture of the stubble on which the boy is rolling and which he must feel through his shirt.

The idea within the event, the idea to which Kertesz was here receptive, concerns the sense of touch. And how in childhood, everywhere, this sense of touch is especially acute. The photograph is lucid because it speaks, through an idea, to our fingertips, or to our memory of what our fingertips felt.

Event and idea are naturally, actively connected. The photograph frames them, excluding everything else. A particular is being equalised with the universal.

In "A Red Hussar Leaving" the idea concerns stillness. Everything is read as movement: the trees against the sky, the folds of their clothes, the scene of departure, the breeze that ruffles the baby's hair, the shadow of the trees, the woman's hair on her cheek, the angle at which the rifles are being carried. And within this flux, the idea of stillness is instigated by the look passing between the woman and the man. And the lucidity of this idea makes us ponder on the stillness which is born in every departure.

A pair of lovers are embracing on a park bench (or in a garden?). They are an urban middle-class couple. They are probably unaware of being

Lovers, May 15, 1915, Budapest (André Kertesz)

photographed. Or if they are aware, they have now almost forgotten the camera. They are discreet – as the conventions of their class would demand on any public occasion, with or without cameras — and yet, at the same time, desire (or the longing for desire) is making them (might make them) abandoned. Such is the not uncommon event. What makes it an uncommon photograph is that the special coherence of everything

we see in it — the concealing screen of the hedge behind them, her gloves, the cuffs of their jackets with the same buttons on them, the movements of their hands, the touching of their noses, the darkness which marries their tailored clothes and the shade of the hedge, the light which illuminates leaves and skin — this coherence instigates the idea of the stroke dividing decorum/desire, clothed/unclothed, occasion/privacy. And such a division is a universal adult experience.

Kertesz himself said: "The camera is my tool. Through it I give reason to everything around me." It may be possible to construct a theory upon the specific photographic process of "giving a reason".

Let us summarise. Photographs quote from appearances. The takingout of the quotation produces a discontinuity, which is reflected in the ambiguity of a photograph's meaning. All photographed events are ambiguous, except to those whose personal relation to the event is such that their own lives supply the missing continuity. Usually, in public the ambiguity of photographs is hidden by the use of words which explain, less or more truthfully, the pictured events.

The expressive photograph — whose expressiveness can contain its ambiguity of meaning and "give reason" to it — is a long quotation from appearances: the length here to be measured not by time but by a greater extension of meaning. Such an extension is achieved by turning the photograph's discontinuity to advantage. The narration is broken. (We do not know why the young man asleep is waiting for a train, supposing that that is what he is doing.) Yet the very same discontinuity, by preserving an instantaneous set of appearances, allows us to read across them and to find a synchronic coherence. A coherence which, instead of narrating, instigates ideas. Appearances have this coherent capacity because they constitute something approaching a language. I have referred to this as a half-language.

The half-language of appearances continually arouses an expectation of further meaning. We seek revelation with our eyes. In life this expectation is only rarely met. Photography confirms this expectation and confirms it in a way which can be shared (as we shared the reading of these photographs by Kertesz). In the expressive photograph, appearances cease to be oracular and become elucidatory. It is this confirmation which moves us.

Apart from the event photographed, apart from the lucidity of the idea, we are moved by the photograph's fulfilment of an expectation which is intrinsic to the will to look. The camera completes the half-language of appearances and articulates an unmistakable meaning. When this happens we suddenly find ourselves at home amongst appearances, as we are at home in our mother tongue.

If each time . . .

Photos by Jean Mohr Narrated by John Berger and Jean Mohr

If each time I had milked a cow somebody had given me a penny, I'd be a rich woman today.

An old Savoyarde peasant woman

We want to describe the indescribable: nature's instantaneous text. We have lost the art of describing the only reality whose structure lends itself to poetic representation: impulses, aims, oscillations.

Osip E. Mandelstam, Entretiens sur Dante

Note to the reader

We are far from wanting to mystify. Yet it is impossible for us to give a verbal key or storyline to this sequence of photographs. To do so would be to impose a single verbal meaning upon appearances and thus to inhibit or deny their own language. In themselves appearances are ambiguous, with multiple meanings. This is why the visual is astonishing and why memory, based upon the visual, is freer than reason.

There is no single "correct" interpretation of this sequence of images. It attempts to follow an old woman's reflections on her life. If she were suddenly asked: What are you thinking about? she would invent a simple answer, because the question, when taken seriously, becomes unanswerable. Her reflections cannot be defined by any answer to a question beginning with What? And yet she was thinking, reflecting, remembering, recalling, and doing so in a consecutive manner. She was making sense of herself to herself.

The ambiguities encountered are not an obstacle to "understanding" this work but a condition for following it, as it attempts to follow, for a few minutes, the mind of an old woman considering her life.

The old woman, like the protagonist of a story, has been invented. Certain facts about her life can be given. She is a peasant woman. She was born in the Alps. She is unmarried and lives by herself. She has lived through two world wars. At a certain moment she went to look for work in the capital, and worked there for a number of years as a domestic servant. Later she returned to her village. She is still active and independent, working most of the day — if there is no snow — outside. In the evening, after she has eaten her soup, she knits. Sometimes she does so while watching television. Sometimes she prefers silence.

By considering her own life, she reflects, like everyone who grows old, on life in general: on being born, on childhood, on work, love, emigration, work, being a woman, death, the village, work, pleasure, solitude, men and women, work, the mountains.

The photographs of this sequence are not intended to be documentary. That is to say, they do not document the woman's life — not even her subjective life. There are photographs included of moments and scenes which she could never have witnessed. For example, in the long sequence concerning the impact of the metropolis on an emigrant born in a village, we have used not only images of Paris but also images of Istanbul. All photographs use the language of appearances. We have tried here to speak this language so as not only to illustrate, but also to articulate a lived experience.

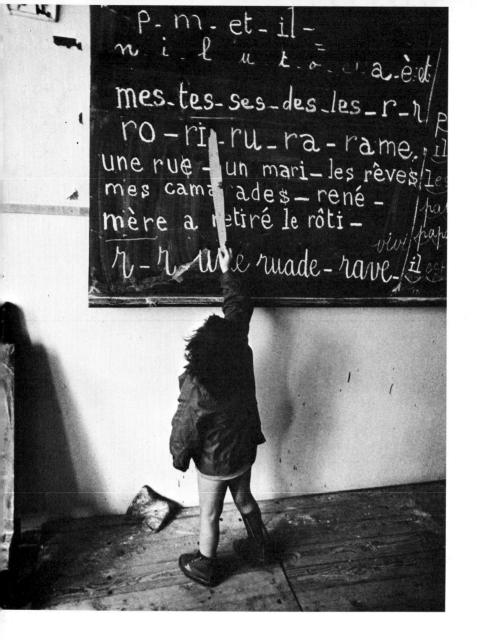

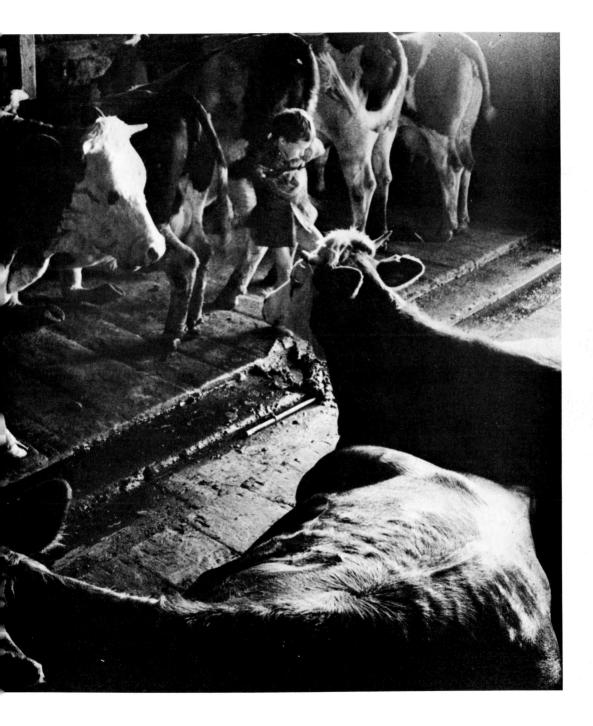

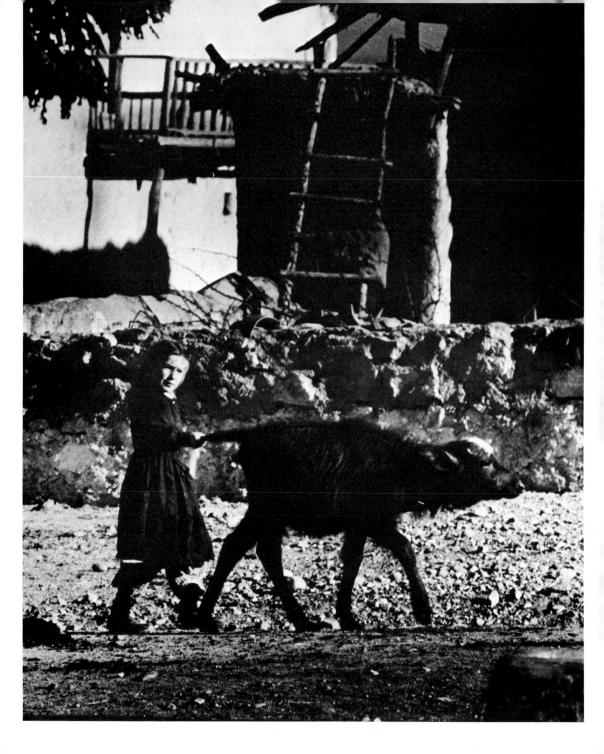

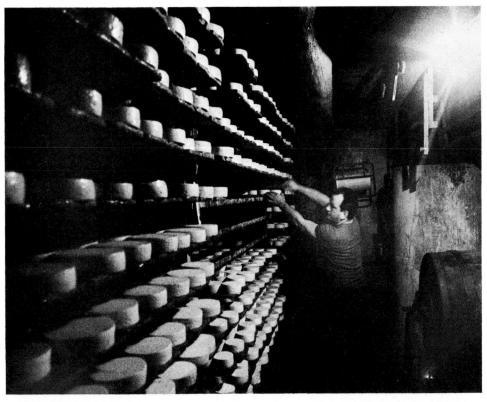

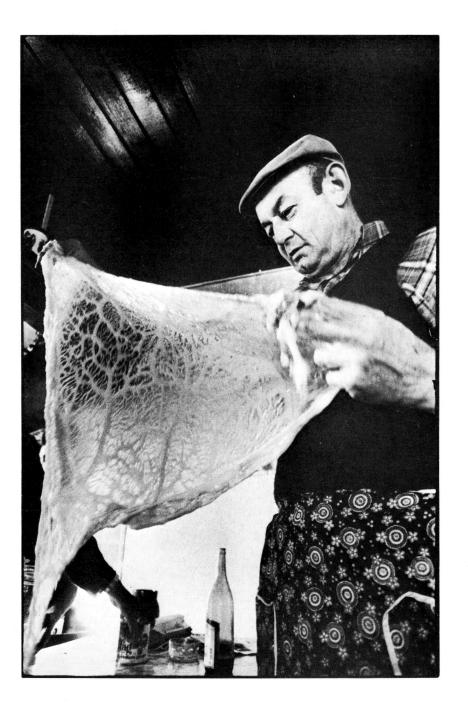

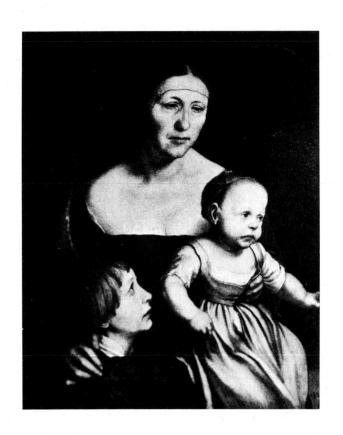

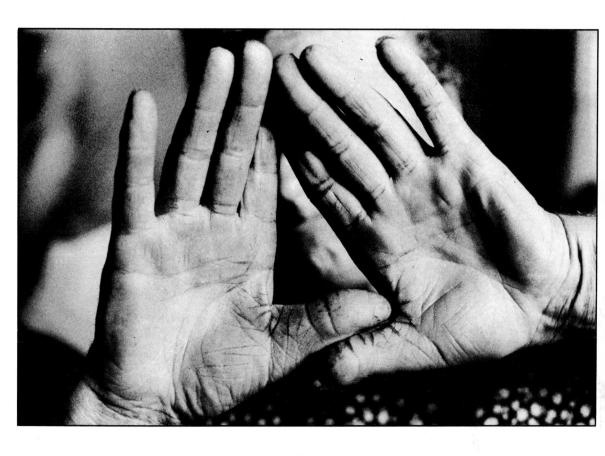

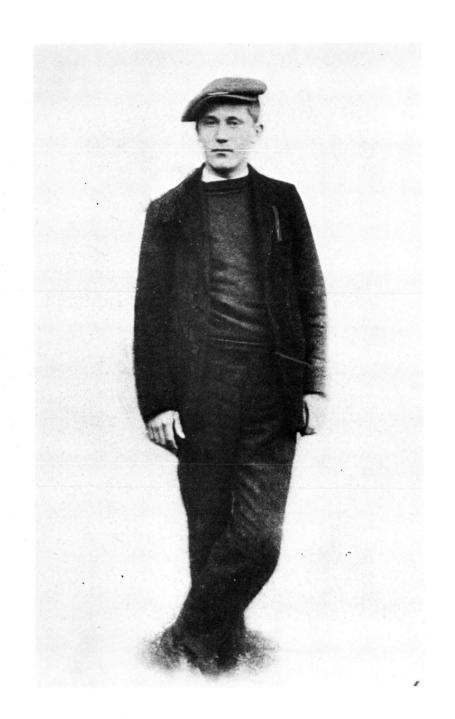

DE FER DU NORD AMASSAOR DE SELECTION DE SELECTION

LONDRES BRUXELLES
PARIS LIEGE

RAILWAY

THERN

LIEGE BERLIN VARSOVIE

COMPAGNIE DES WAGONS - LITS

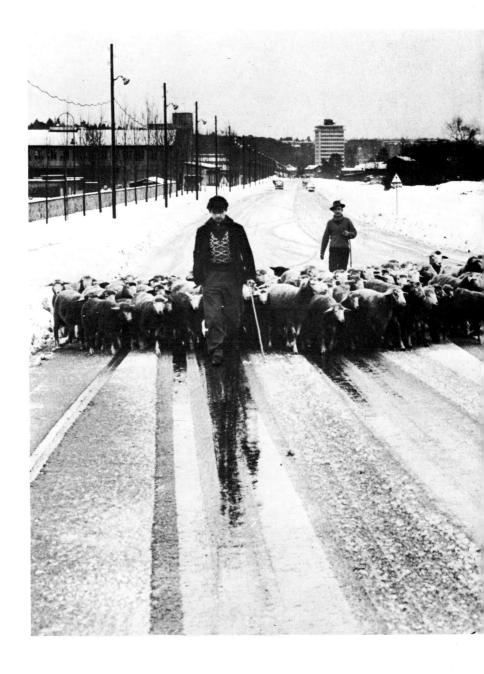

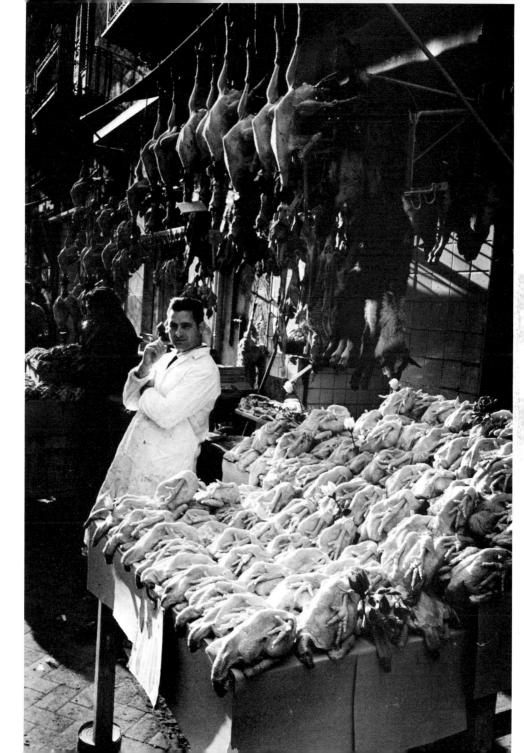

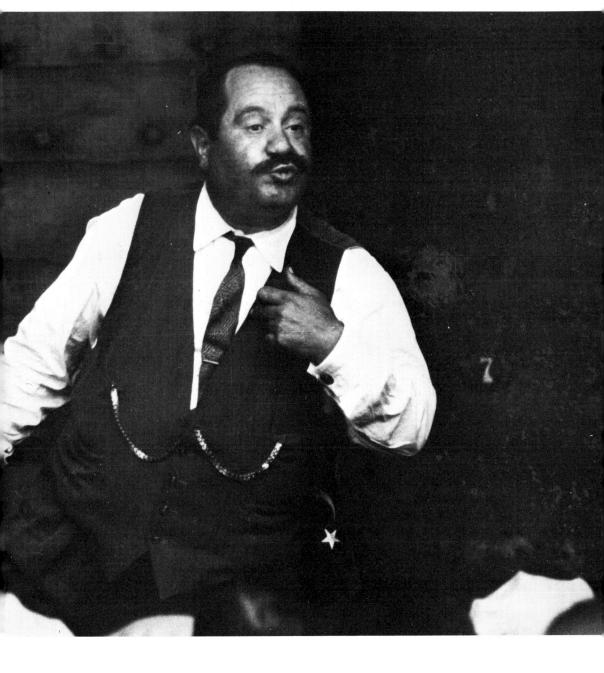

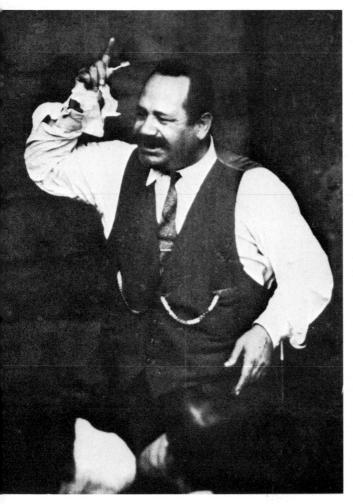

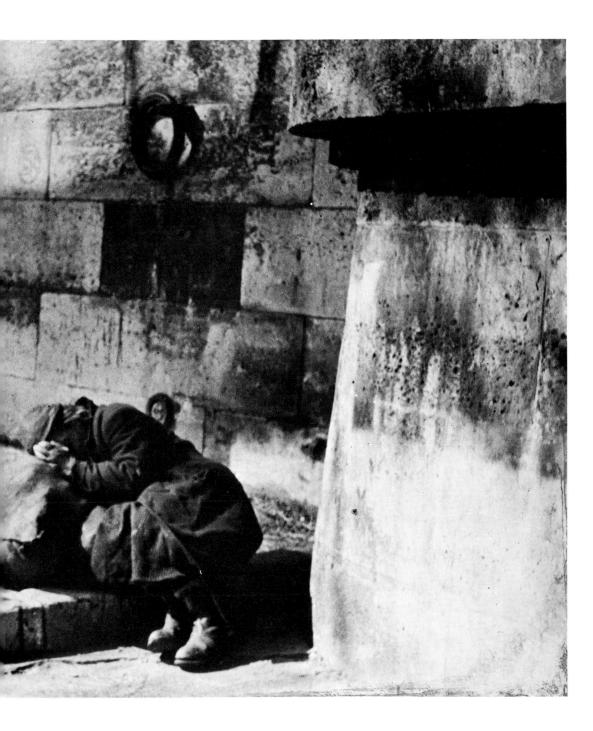

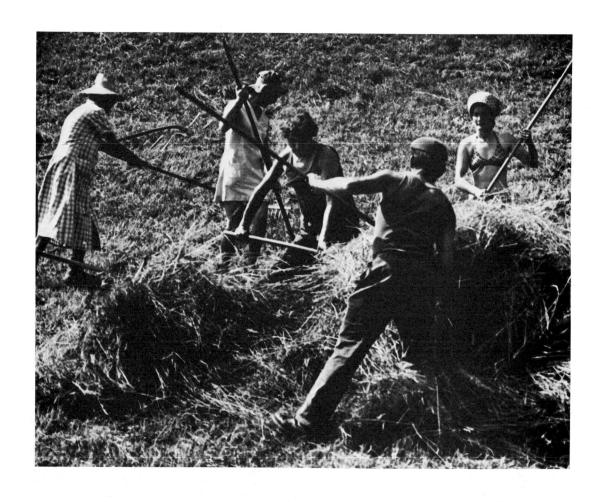

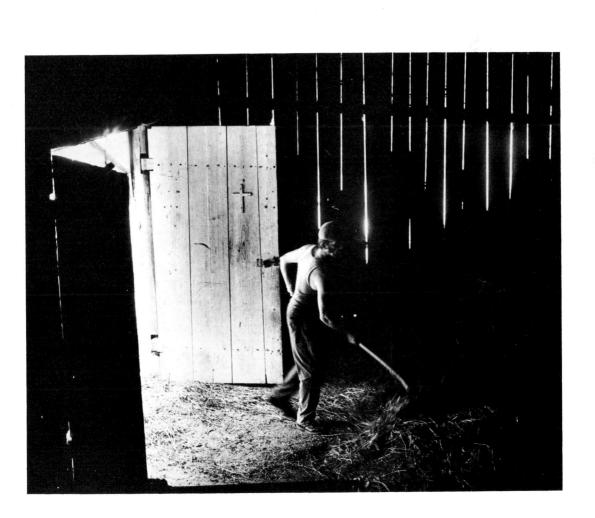

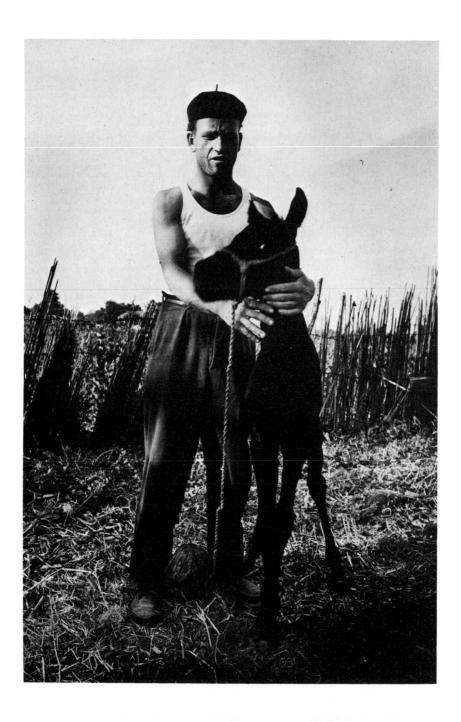

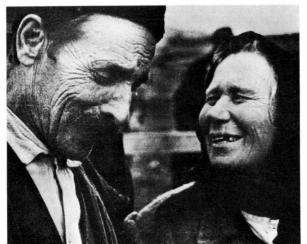

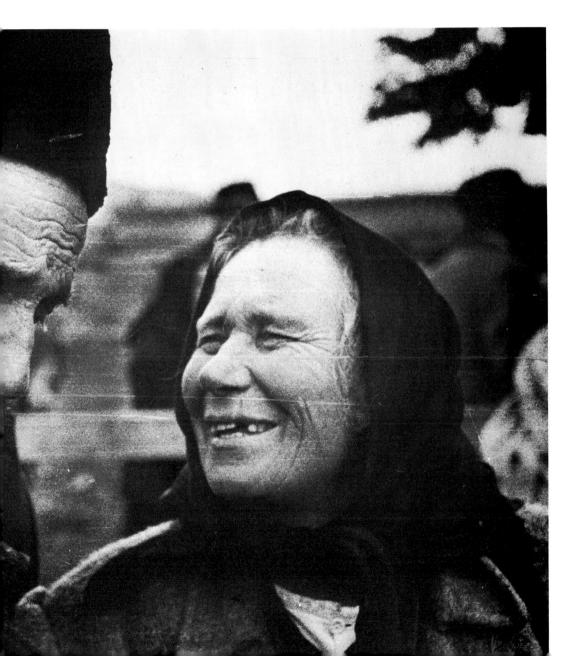

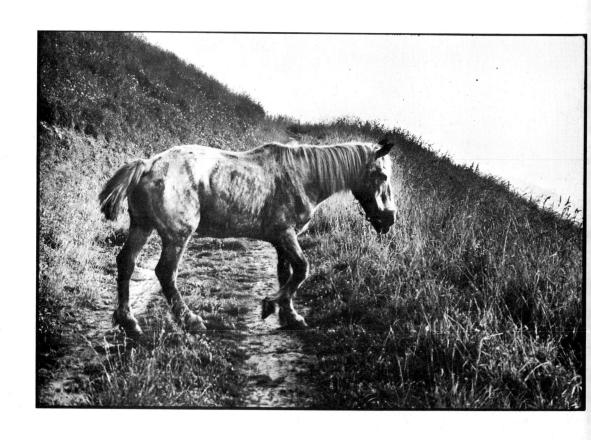

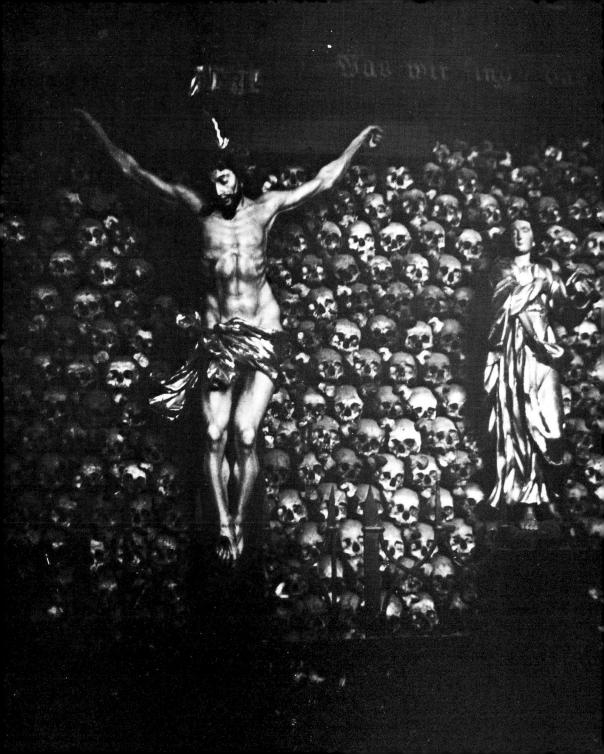

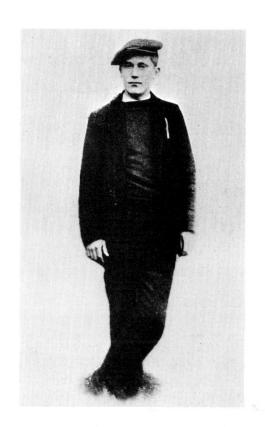

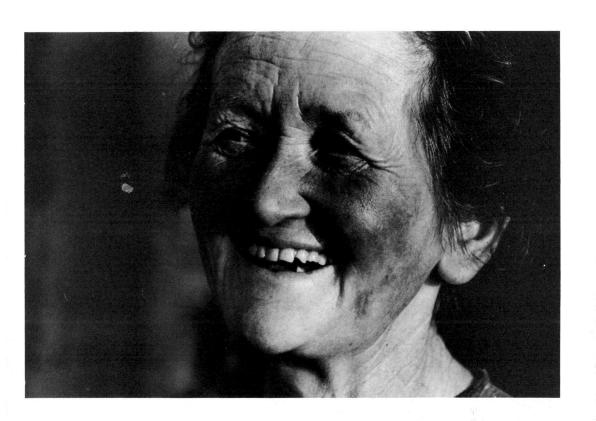

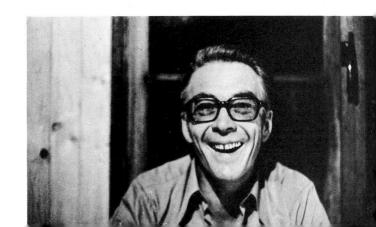

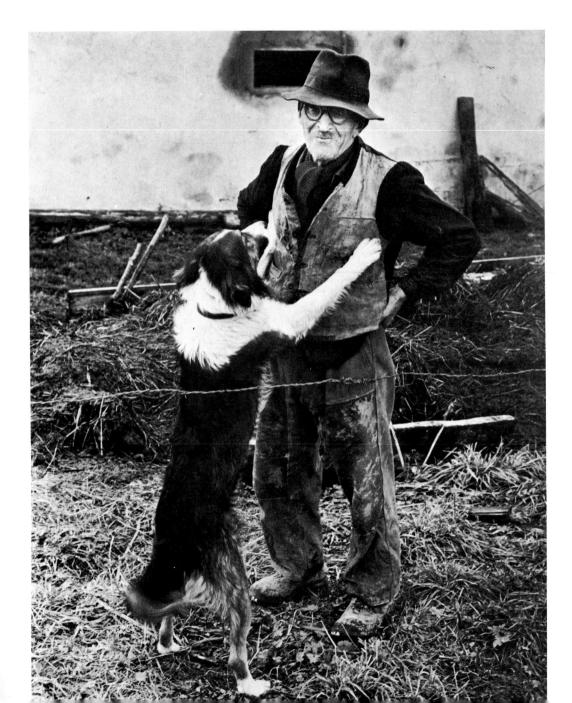

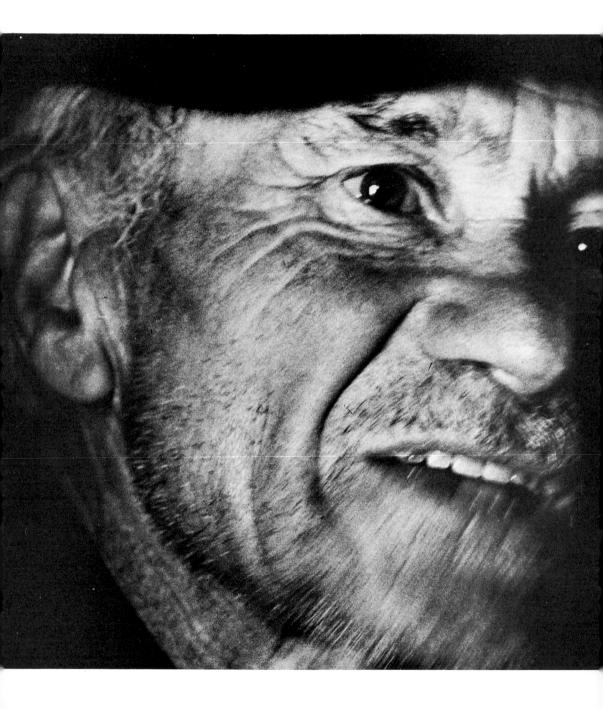

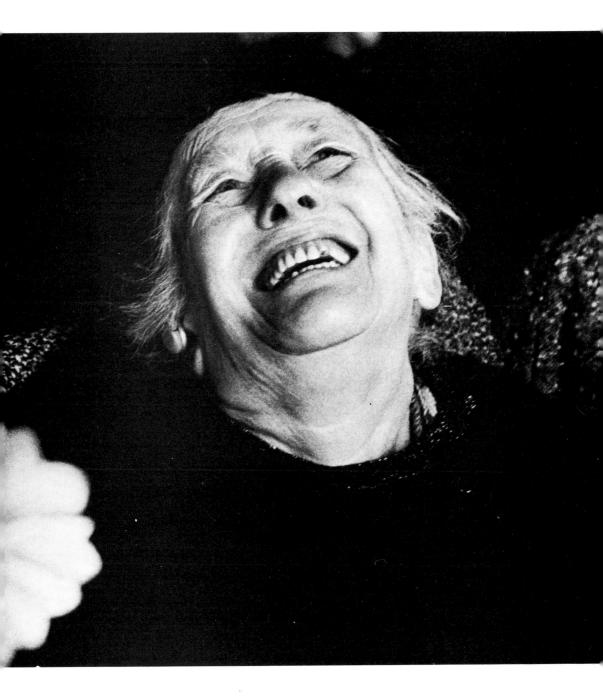

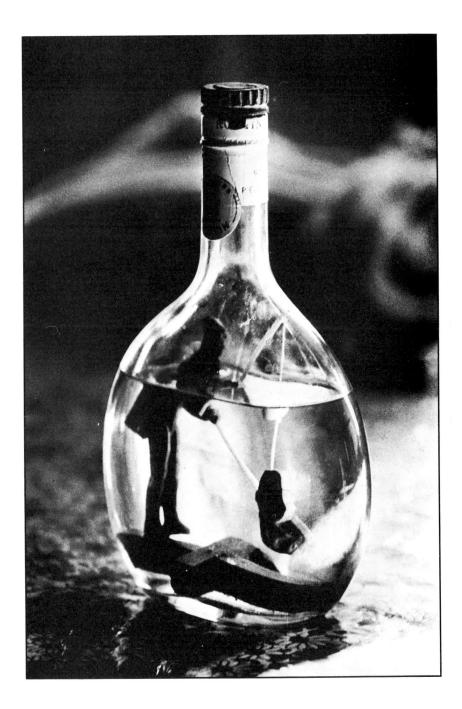

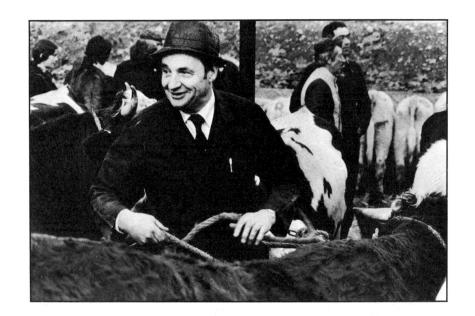

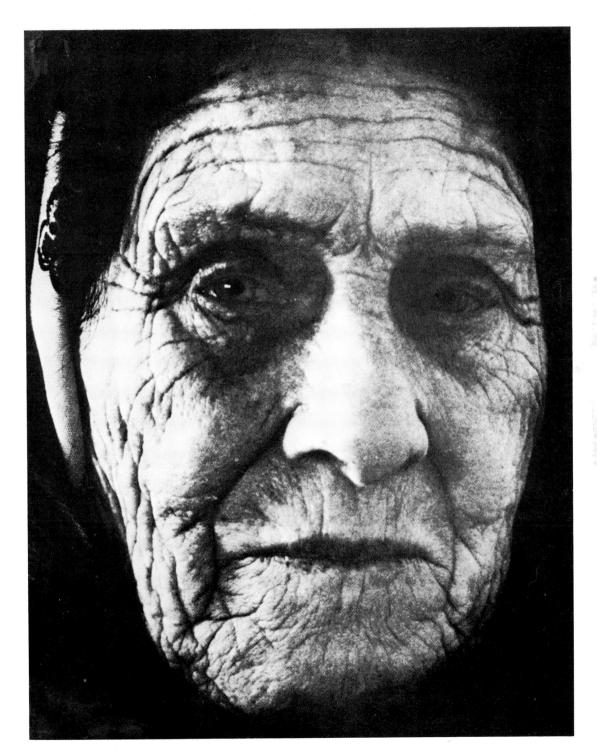

Stories

by John Berger

If photographs quote from appearance and if expressiveness is achieved by what we have termed the long quotation, then the possibility suggests itself of composing with numerous quotations, of communicating not with single photographs but with groups or sequences. But how should these sequences be constructed? Can one think in terms of a truly photographic narrative form?

There is already an established photographic practice which uses pictures in sequence: the reportage photo-story. These certainly narrate, but they narrate descriptively from the outsider's point of view. A magazine sends photographer X to city Y to bring back pictures. Many of the finest photographs taken belong to this category. But the story told is finally about what the photographer saw at Y. It is not directly about the experience of those living the event in Y. To speak of their experience with images it would be necessary to introduce pictures of other events and other places, because subjective experience always connects. Yet to introduce such pictures would be to break the journalistic convention.

Reportage photo-stories remain eye-witness accounts rather than stories, and this is why they have to depend on words in order to overcome the inevitable ambiguity of the images. In reports ambiguities are unacceptable; in stories they are inevitable.

If there is a narrative form unique to photography, will it not resemble that of the cinema? Surprisingly, photographs are the opposite of films. Photographs are retrospective and are received as such: films are anticipatory. Before a photograph you search for what was there. In a cinema you wait for what is to come next. All film narratives are, in this sense, adventures: they advance, they arrive. The term flashback is an admission of the inexorable impatience of the film to move forward.

By contrast, if there is a narrative form intrinsic to still photography, it

will search for what happened, as memories or reflections do. Memory itself is not made up of flashbacks, each one forever moving inexorably forward. Memory is a field where different times coexist. The field is continuous in terms of the subjectivity which creates and extends it, but temporarily it is discontinuous.

Amongst the ancient Greeks, Memory was the mother of all the Muses, and was perhaps most closely associated with the practice of poetry. Poetry at that time, as well as being a form of story-telling, was also an inventory of the visible world; metaphor after metaphor was given to poetry by way of visual correspondences.

Cicero, discussing the poet Simonides who was credited with the invention of the art of memory, wrote: "It has been sagaciously discerned by Simonides or else discovered by some other person, that the most complete pictures are formed in our minds of the things that have been conveyed to them and imprinted on them by the senses, but that the keenest of all our senses is the sense of sight, and that consequently perceptions received by the ears or by reflection can be most easily retained if they are also conveyed to our minds by the mediation of the eyes."

A photograph is simpler than most memories, its range more limited. Yet with the invention of photography we acquired a new means of expression more closely associated with memory than any other. The Muse of photography is not one of Memory's daughters, but Memory herself. Both the photograph and the remembered depend upon and equally oppose the passing of time. Both preserve moments, and propose their own form of simultaneity, in which all their images can coexist. Both stimulate, and are stimulated by, the inter-connectedness of events. Both seek instants of revelation, for it is only such instants which give full reason to their own capacity to withstand the flow of time.

Photographs can relate the particular to the general. This happens, as I have shown, even within a single picture. When it happens across a number of pictures, the nexus of relative affinities, contrasts and comparisons can be that much wider and more complex.

The following sequence, taken from the book A Seventh Man, was intended to speak about a migrant worker's sexual deprivation. By using four photographs instead of one, the telling, we hoped, would go beyond the simple fact — which any good photo-reportage would show — that many migrant workers live without women.

In this book we have built a sequence of, not four, but a hundred and fifty images. It is entitled "If Each Time —". Otherwise there is no text. No words redeem the ambiguity of the images. The sequence begins with certain memories of a childhood, but it does not then follow a chronology. There is no story-line as there is in a *photo-roman*. There is, as it were, no seat supplied for the reader. The reader is free to make his own way *through* these images. The first reading across any two pages may tend to proceed from left to right like European print, but subsequently one can wander in any direction without, we hope, losing a sense of tension or unfolding. Nevertheless we constructed the sequence *as a story*. It is intended to narrate. What can it mean to assert this? If such a thing exists, what is the photographic narrative form?

* *

To try to answer the question, let me first return to the traditional story.

The dog came out of the forest is a simple statement. When that sentence is followed by The man left the door open, the possibility of a narrative has begun. If the tense of the second sentence is changed into The man had left the door open, the possibility becomes almost a promise. Every narrative proposes an agreement about the unstated but assumed connections existing between events.

One can lie on the ground and look up at the almost infinite number of stars in the night sky, but in order to tell stories about those stars they need to be seen as constellations, the invisible lines which can connect them need to be assumed.

No story is like a wheeled vehicle whose contact with the road is continuous. Stories walk, like animals or men. And their steps are not

only between narrated events but between each sentence, sometimes each word. Every step is a stride over something not said.

The suspense story is a modern invention (Poe, 1809–1849) and consequently today one may tend to overestimate the role of suspense, the waiting-for-the-end, in story-telling. The essential tension in a story lies elsewhere. Not so much in the mystery of its destination as in the mystery of the spaces between its steps towards that destination.

All stories are discontinuous and are based on a tacit agreement about what is not said, about what connects the discontinuities. The question then arises: Who makes this agreement with whom? One is tempted to reply: The teller and the listener. Yet neither teller nor listener is at the centre of the story: they are at its periphery. Those whom the story is about are at the centre. It is between their actions and attributes and reactions that the unstated connections are being made.

One can ask the same question in another way. When the tacit agreement is acceptable to the listener, when a story makes sense of its discontinuities, it acquires authority as a story. But where is this authority? In whom is it invested? In one sense, it is invested in nobody and it is nowhere. Rather, the story invests with authority its characters, its listener's past experience and its teller's words. And it is the authority of all these together that makes the action of the story — what happens in it — worthy of the action of its being told, and vice versa.

The discontinuities of the story and the tacit agreement underlying them fuse teller, listener and protagonists into an amalgam. An amalgam which I would call the story's *reflecting subject*. The story narrates on behalf of this subject, appeals to it and speaks in its voice.

If this sounds unnecessarily complicated, it is worth remembering for a moment the childhood experience of being told a story. Were not the excitement and assurance of that experience precisely the result of the mystery of such a fusion? You were listening. You were in the story. You were in the words of the story-teller. You were no longer your single self; you were, thanks to the story, *everyone it concerned*.

The essence of that childhood experience remains in the power and appeal of any story which has authority. A story is not simply an exercise in empathy. Nor is it merely a meeting-place for the protagonists, the listener and the teller. A story being told is a unique process which fuses these three categories into one. And ultimately what fuses them, within the process, are the discontinuities, the silent connections, agreed upon in common.

* *

Supposing one tries to narrate with photography. The technique of the *photo-roman* offers no solution, for there photography is only a means of reproducing a story constructed according to the conventions of the cinema or theatre. The characters are actors, the world is a decor. Supposing one tries to arrange a number of photographs, chosen from the billions which exist, so that the arrangement speaks of experience. Experience as contained within a life or lives. If this works, it may suggest a narrative form specific to photography.

The discontinuities within the arrangement will be far more evident than those in a verbal story. Each single image will be more or less discontinuous with the next. Continuities of time, place or action may occur, but will be rare. On the face of it there will be no story. And yet in story-telling, as I have tried to show above, it is precisely an agreement about discontinuities which allows the listener to "enter the narration" and become part of its reflecting subject. The essential relation between teller, listener (spectator) and protagonist(s) may still be possible with

an arrangement of photographs. It is, I believe, only their roles, relative to one another, which are modified, not their essential relationship.

The spectator (listener) becomes more active because the assumptions behind the discontinuities (the unspoken which bridges them) are more far-reaching. The teller becomes less present, less insistent, for he no longer employs words of his own; he speaks only through quotations, through his choice and placing of the photographs. The protagonist (at least in our story) becomes omnipresent and therefore invisible; she is manifest in each connection made. One might say that she is defined by the way she wears the world, the world about which the photographs supply information. Before she wears it, it is her experience which sews it together.

If, despite these changes of role, there is still the fusion, the amalgam of the *reflecting subject*, one can still talk of a narrative form. Every kind of narrative situates its reflecting subject differently. The epic form placed it before fate, before destiny. The nineteenth century novel placed it before the individual choices to be made in the area where public and private life overlap. (The novel could not narrate the lives of those who virtually had no choice.) The photographic narrative form places it before the task of memory: the task of continually *resuming* a life being lived in the world. Such a form is not concerned with events as facts — such as is always claimed for photography; it is concerned with their assimilation, their gathering and their transformation into experience.

The precise nature of this as yet experimental narrative form may become still clearer if I very briefly discuss its use of montage. If it does narrate, it does so through its montage.

Eisenstein once spoke of "a montage of attractions". By this he meant that what precedes the film-cut should attract what follows it, and vice versa. The energy of this attraction could take the form of a contrast, an equivalence, a conflict, a recurrence. In each case, the cut becomes eloquent and functions like the hinge of a metaphor. The energy of such a montage of attractions could be shown like this:

Yet there was in fact an intrinsic difficulty in applying this idea to film. In a film, with its thirty-two frames per second, there is always a third energy in play: that of the reel, that of the film's running through time. And so the two attractions in a film montage are never equal. They are like this:

In a sequence of still photographs, however, the energy of attraction, either side of a cut, does remain equal, two-way and *mutual*. Such an energy then closely resembles the stimulus by which one memory triggers another, irrespective of any hierarchy, chronology or duration.

In fact, the energy of the montage of attractions in a sequence of still photographs destroys the very notion of *sequences* — the word which, up to now, I have been using for the sake of convenience. The sequence has become a field of coexistence like the field of memory.

Photographs so placed are restored to a living context: not of course to the original temporal context from which they were taken — that is impossible — but to a context of experience. And there, *their ambiguity at last becomes true*. It allows what they show to be appropriated by reflection. The world they reveal, frozen, becomes tractable. The information they contain becomes permeated by feeling. Appearances become the language of a lived life.

The darkness of night is far from the living as granite 5:00 am. November

On the panes minus fifteen grow flowers of ice 5:00 am. December

The morning stove is dead and silent as the wood of the frozen trees 5:00 am. January

On waking sleep solicits another visit to her summers 5:00 am. February

Declining he farts lights the fire goes out with his churn 5:30 am.

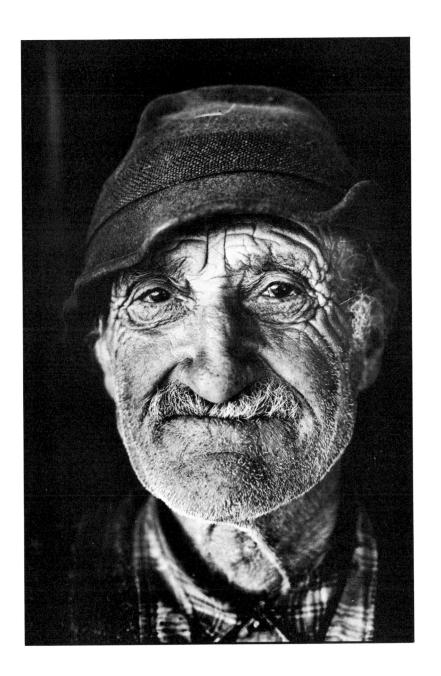

List of photographs

Beyond my camera

- 10 Cattle-dealer with cows, Bonneville, 1979 (photo: Jean Mohr)
- 12 Aligarh, India, 1968 (photo: Jean Mohr)
- 14 Ibid
- 15 Ibid
- 16-35 Roche-Pallud, The Sommand Plateau, 1978 (photo: Jean Mohr)
- 37 Ibid
- 38 "Moved" self-portrait, 1975 (photo: Jean Mohr)
- 39 Jean Mohr, 1980 (photo: Richard Derviaz)
- 41 Young refugee from an Eastern country, Trieste Reception Centre, 1965 (photo: Jean Mohr)
- 43 West Germany, 1975 (photo: Jean Mohr)
- 44 Washington, 1971 (photo: Jean Mohr)
- 45 Srilanka, 1973 (photo: Jean Mohr)
- 46 Great Britain, 1964 (photo: Jean Mohr)
- 47 India, 1968 (photo: Jean Mohr)
- 58-71 Sommand, 1978 (photo: Jean Mohr)
- 72-75 Indonesia, 1973 (photo: Jean Mohr)
 - 76 Belgrade, 1957 (photo: Jean Mohr)

Appearances

- 85 Man with the horse
- 88 Indonesian girl (photo: Jean Mohr)
- 90 Nazis burning books (Imperial War Museum)
- 91 Publicity for champagne
- 94 Olive trees in Provence (photo: John Berger)
- 94 Drawing by Vincent Van Gogh
- 101 A Red Hussar leaving, June 1919, Budapest (photo: André Kertesz)
- 110 Peaches on a plate by Paul Cézanne
- 113 Butterfly

- 113 Baby at breast (photo: Saul Landau)
- 123 Boy sleeping, May 25, 1912, Budapest (photo: André Kertesz)
- 125 Friends, September 3, 1917, Esztergan (photo: André Kertesz)
- 127 Lovers, May 15, 1915, Budapest (photo: André Kertesz)

If each time . . . (All photos are by Jean Mohr unless otherwise indicated.)

- 135 J.'s hands
- 135 Document
- 136 A spring, Haute-Savoie
- 137 A spring in the alpage, Haute-Savoie
- 138 Document, detail
- 139 In a meadow, Val d'Aoste
- 139 Document, Russian painting
- 140 Village in the Tatry Mountains, Poland
- 141 Poland
- 142 Mother and child's hand, Great Britain
- 143 Poland
- 144 Document
- 145 A spring
- 146 J.'s hands
- 147 Paris
- 148 Tunisia
- 149 Geneva, bird tracks
- 150 School in the Township of Mieussy
- 151 Rabbit skeletons, Haute-Savoie
- 152 *Ibid*
- 153 Katya (photo: John Berger)
- 154 School
- 156 Foundation of a chalet, Norway
- 157 Document
- 158 Children going to the dairy, Fribourg, Switzerland
- 158 On the road to Sommand, Haute-Savoie
- 159 *Ibid*
- 160 Six in the morning at the dairy, Haute-Savoie

- 161 The dairy
- 162 Ibid
- 163 *Ibid*
- 164 J.'s hands
- 165 Document, emigration
- 166 Little girl, Fribourg
- 167 A stable in the alpage, Haute-Savoie
- 168 Cow's udder
- 169 Clouds, Valais, Switzerland
- 170 Dairy, Haute-Savoie
- 171 *Ibid*
- 172 Village scene, Turkey
- 173 Rabbit, Haute-Savoie
- 174 Dairy, Haute-Savoie
- 174 Cheese cellar, Haute-Savoie
- 175 Cutting up a pig, Haute-Savoie
- 176 Document, painting by Holbein
- 177 J.'s hands
- 178 Document, Haute-Savoie179 A toy made in the Haute Savoie
- 180 A Geneva suburb
- 181 *Ibid*
- 182 Document, poster
- 183 A Geneva suburb
- 184 Paris
- 185 J.'s hands
- 186 Istanbul
- 187 *Ibid*
- 188 Palermo
- 188 Istanbul
- 189 Palermo
- 190 Shoe-shine, Istanbul
- 191 Istanbul
- 192 Document, Russian painting
- 193 Camelot, Istanbul
- 194 *Ibid*
- 195 *Ibid*

- 196 A spring, Haute-Savoie
- 197 Document
- 198 Document, postcard
- 199 Hotel Schweizerhof, Berne
- 200 A chalet in the alpage, Haute-Savoie
- 200 By the door, Haute-Savoie
- 201 Document, the home of Auguste Perret
- 202 Hotel Schweizerhof, Berne
- 203 Among cows, Haute-Savoie
- 204 Vagrant on the banks of the Seine
- 205 Ibid
- 207 J.'s hands
- 208 Document, sculpture of trousers
- 209 Peasant, Savoie
- 210 Hay-making, Haute-Savoie
- 211 Rumanian peasant
- 212 Hay-making, Haute-Savoie
- 213 Barn, Haute-Savoie
- 214 J.'s hands
- 215 *Ibid*
- 216 Danube delta, Rumania
- 217 Peasant, Switzerland
- 218 Document, Millet
- 219 *Ibid*
- 219 Peasants, Yugoslavia
- 221 Ibid
- 222 Chalet, Haute-Savoie
- 223 *Ibid*
- 224 Cemetery, Haute-Savoie
- 225 A ploughed field, Vaud, Switzerland
- 225 Before the harvest, Vaud
- 226 Hay-making, Valais, Switzerland
- 227 Decorated café, eagle, Haute-Savoie
- 228 Document, Haute-Savoie
- 229 Charnel house, Sainte-Catherine, Sinai
- 230 Old horse, Haute-Savoie
- 231 Charnel house, Haut-Valais

- 232 *Ibid*
- 232 J.'s hands
- 233 Ibid
- 234 Document, Haute-Savoie
- 234 Summer festival, Yugoslavia
- 235 Sunday for the old ones, Haute-Savoie
- 236 Distillery, Haute-Savoie
- 236 Empty glass, Haute-Savoie
- 237 Document, Haute-Savoie
- 237 Document, painting, Haute-Savoie
- 238 Document, Haute-Savoie
- 239 Washing drying in the sun, Sicily
- 240 Festival of the old ones, Haute-Savoie
- 241 Marcelle, Haute-Savoie
- 242 Peasant and dog, Haute-Savoie
- 243 Decorated café, stuffed fox, Haute-Savoie
- 244 Festival of the old ones, Haute-Savoie
- 245 Yugoslavia
- 246 Ibid
- 247 Festival of the old ones, Haute-Savoie
- 248 Farm annexe, Haute-Savoie
- 249 A fanciful bottle, Haute-Savoie
- 250 January, Geneva
- 251 Cutting up the pig, Haute-Savoie
- 252 Ibid
- 253 Cattle merchants, Tessin, Switzerland
- 253 Cutting up the pig, Haute-Savoie
- 254 Ibid
- 255 Tree stump, Haute-Savoie
- 256 Cutting up the pig
- 257 Cattle merchant, Haute-Savoie
- 257 J.'s scarf
- 258 Clouds, Glaris, Switzerland
- 259 Old woman, Tunisia
- 260 Sardinian sculpture of Christ
- 261 Dresser, Haute-Savoie
- 261 Landscape, Haute-Savoie

- 262 Potato farm, Yugoslavia
- 263 Etrurian orchard, Italy
- 264 Working the fields, Valais
- 265 Ploughing in Greece
- 266 Katya (photo: John Berger)
- 267 Decorated café, Haute-Savoie
- 268 Document
- 269 J.'s hands
- 270 Summer landscape, Haute-Savoie
- 271 *Ibid*
- 272 Winter landscape, Haute-Savoie
- 273 Ibid
- 274 Entrance to a farm, Haute-Savoie
- 275 Ibid

Stories

- 282 Old woman at market, Greece (photo: Jean Mohr)
- 282 Madonna by Perugino (National Gallery, London)
- 283 Walls in migrant workers lodgings, Switzerland (photo: Jean Mohr)
- 283 Young peasant woman (photo: Jean Mohr)
 (The above four images are from *A Seventh Man* by John Berger and Jean Mohr, Penguin Books, 1975)

Beginning

293 Portrait, Roche-Pallud, 1978 (photo: Jean Mohr)

ABOUT THE AUTHOR

John Berger, born in London in 1926, is well known as an art critic, novelist, and film scriptwriter. His many books, innovative in form and far-reaching in their historical and political insight, include *Ways of Seeing, Art and Revolution, The Success and Failure of Picasso*, and the award-winning novel *G*. His films with Alain Tanner include *La Salamandre* and *Jonah Will Be 25 in the Year 2000*. Respected for his uncompromising judgements on art, Berger is one of Britain's most influential art critics.

He now lives in a small French peasant community, where he has recently completed *Lilac and Flag*, the third volume of his trilogy, *Into Their Labours* (which also includes *Pig Earth* and *Once in Europa*).

WORKS BY IOHN BERGER

"Berger is one of the most gifted and imaginative contemporary writers."

- The New York Times

Fiction

The Into Their Labours trilogy
PIG EARTH Fiction/Literature/0-679-73715-4
ONCE IN EUROPA Fiction/Literature/0-679-73716-2

LILAC AND FLAG Fiction/Literature/0-679-73719-7

CORKER'S FREEDOM Fiction/Literature/0-679-75513-6

A PAINTER OF OUR TIME Fiction/0-679-72271-8

G. Fiction/Literature/0-679-73654-9

Art Criticism

ABOUT LOOKING Art Criticism/0-679-73655-7

AND OUR FACES, MY HEART, BRIEF AS PHOTOS Essays/Art Criticism/0-679-73656-5

ANOTHER WAY OF TELLING Photography/Art Criticism/0-679-73724-3

ART AND REVOLUTION Art Criticism/0-394-41562-0

KEEPING A RENDEZVOUS Art Criticism/0-679-73714-6

THE SENSE OF SIGHT Art Criticism/0-679-73722-7

THE SUCCESS AND FAILURE OF PICASSO Art Criticism/0-679-73725-1

Available at your local bookstore, or call toll-free to order: 1-800-793-2665 (credit cards only).